St. Louis
1875–1940

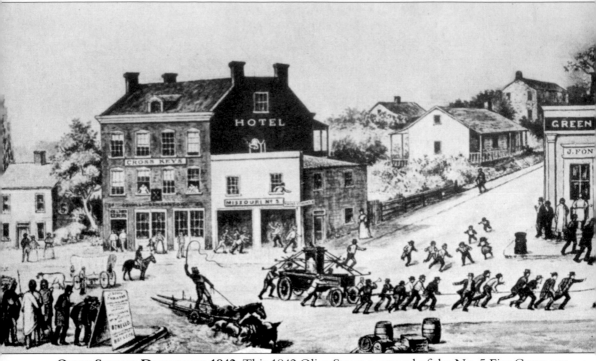

OLIVE STREET DEPICTION 1842. This 1842 Olive Street portrayal of the No. 5 Fire Company responding to a clanging bell alarm only hints at the future great city about to unfold.

POSTCARD HISTORY SERIES

St. Louis
1875–1940

Joan M. Thomas

ARCADIA

Published by Arcadia Publishing,
an imprint of Tempus Publishing, Inc.
Charleston SC., Chicago, Portsmouth NH,
San Francisco

Printed in Great Britain.

Library of Congress Catalog Card Number: Applied For.

For all general information contact Arcadia Publishing at:
Telephone 843-853-2070
Fax 843-853-0044
E-Mail sales@arcadiapublishing.com
For customer service and orders:
Toll-Free 1-888-313-2665

Visit us on the internet at http://www.arcadiapublishing.com

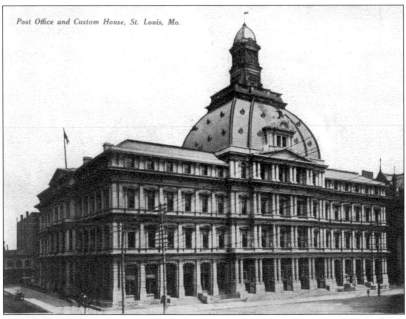

Post Office and Custom House, St. Louis, Mo.

POST OFFICE AND CUSTOM HOUSE. St. Louis history comes alive with postcards picturing some of the city's still-existing grand buildings. More than 11 years in the making, with vexing construction problems and 17 separate Congressional appropriations, this mammoth building now called the "Old Post Office" opened in 1884. Covering the land bordered by Olive, Eighth, Locust, and Ninth, it was intended as a veritable fortress for the Federal Government. It was a Federal Court House as well as Post Office and Custom House. The cast iron cupola on top is now gone, but the building remains, though no longer used for its original purposes.

CONTENTS

ACKNOWLEDGMENTS

Without the kindness and generosity extended to me by the following individuals, this project would be a mere figment of my imagination. My scant collection of postcards would not begin to fill the pages of this book.

First and foremost, I want to thank Fred Longshaw, of Fred Longshaw Postcards in Des Peres. Not only did he allow me access to his vast collection, he offered invaluable information that would have taken me years to uncover. Additionally, I want to extend my sincere gratitude to Lois Waninger and Ron Bolte of the Carondelet Historical Society. They graciously allowed me to scan some of the society's vintage postcards, many from Lois's personal collection. Plus, the members of the Gateway Postcard Collectors Club have been both an inspiration and a resource. Others deserving honorable mention are Curtis and Ward from Computer Express for their expert technical advice and assistance; Sharon Huffman, Saint Louis Public Schools Archivist; Bob Moore, of the National Park Service; Sister Mary Gavan, of the Sacred Heart National Archives; Pearse Mullally, of the St. Louis Water Department; Tracy Lauer, of Anheuser-Busch Public Relations; and officials of the First Presbyterian Church, the Serbian Eastern Orthodox Church Holy Trinity, and the Shiloh Temple Church of God in Christ. Last, but by far most important, I wish to thank Bob Thomas, my husband, friend, mentor, and chauffeur who unfailingly supports my efforts.

INTRODUCTION

The vehicle of communication that in certain circles is still called a "penny postcard" began in the 19th century. Postcards date back to about 1861, when one side was used for the address, and the reverse for the message. Most of these early cards were used for advertising purposes. Then, the first view cards, or picture postcards, made their appearance around 1893. At first, the message was written on the side with the picture. For example, look at the blank space in the center of the card featuring Tony Faust's Restaurant on page 41.

By the time of the 1904 Louisiana Purchase Exposition, better known as the St. Louis World's Fair, the practice of sending cards from vacation spots was in high gear. As it is with most new ideas, some folks at first vilified the practice, warning that it would end the time-honored art of letter writing. One could liken it to today's concern about possible overuse of email as opposed to what some call "snail-mail." But, here we are more than a century later, and anyone visiting a foreign city or country is expected to send us a card as evidence that we were really there.

The popularity of the picture postcard dwindled somewhat after the first few decades of the twentieth century, and leveled off to what it is today. Naturally, the cost of mailing a postcard has risen along with everything else. There are more than a few generations of adults today who cannot imagine anything ever costing a penny. Yet, we all get postcards reminding us of meetings, elections, appointments, etc. And most of us are thrilled, or jealous, when the postman delivers us a card with a scenic view of some distant land, the writing on the back saying, "Wish you were here!"

Hundreds of old picture postcards still in existence allow us to see St. Louis at another time. Thanks to the dedication and passion of collectors, these images of bygone days are preserved and protected. In the St. Louis area, members of the Gateway Postcard Collectors Club, as well as area historical societies, are the primary guardians of these vintage keepsakes. Although some cards, like many antiques, are quite valuable, true aficionados appreciate each one for its uniqueness and/or historical importance. One can ask any member of the club about a certain place or building in St. Louis and get a concise answer. If that person it not sure, you can bet that at least one other collector will know. They gained that knowledge through their intense study of the places pictured on the cards that they collect. A newcomer to the hobby, the author of this book, discovered more about St. Louis than she ever imagined by researching information for the images' captions. Most notable, she learned to appreciate the profound impact of the 1904 World's Fair on the city of St. Louis.

Authorities speculate that the amount of postcards issued for the 1904 Fair were the largest ever for an American exposition. In Chapter 10, you will see a variety of those cards. What is

most amazing is that all but one of the buildings erected on the fairgrounds for that event are gone. The Art Museum was the only one built to last. Nevertheless, outside the fairgrounds, the city of St. Louis gained a number of permanent and wonderful buildings. Even our water supply was enhanced in preparation for the Fair.

Although some of St. Louis's once-prized buildings have been destroyed, and much of the landscape has been altered, the city is still blessed with more than just remnants of the past. The devastating events of September 11, 2001 demonstrated the vulnerability of fortress-like structures. Now, we can truly appreciate the dedication and heroic efforts of modern preservationists and visionaries. Not only have they managed to save many of the buildings and places seen on the pages to follow, in many cases they have effected rebirth and revitalization.

There are a great many more vintage St. Louis picture postcards than the ones shown in this book. Yet, this fair sampling pictures many places of importance over the city's life just before and during its introduction to horseless transportation. Most importantly, it allows not only a tour of its streets; it provides a sense of what we were and how we got to be what we are today.

One

CITY STREETS

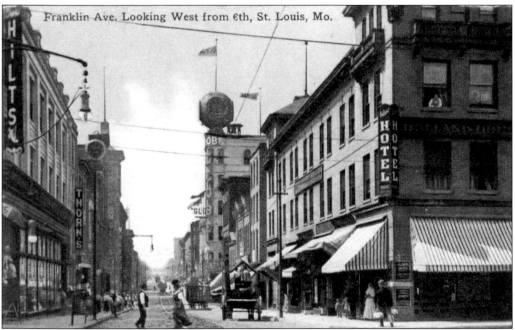

Franklin Ave. Looking West from 6th, St. Louis, Mo.

FRANKLIN AVENUE LOOKING WEST FROM SIXTH. This postcard photo conveys the flavor of St. Louis's early 20th century downtown streets. The large globe seen in the center probably sat atop the Globe Theatre that then existed at 719 Franklin. Over time, these buildings, and even this section of Franklin, yielded to the advances of urban renewal. They were situated somewhere in the area of today's Edward Jones Dome.

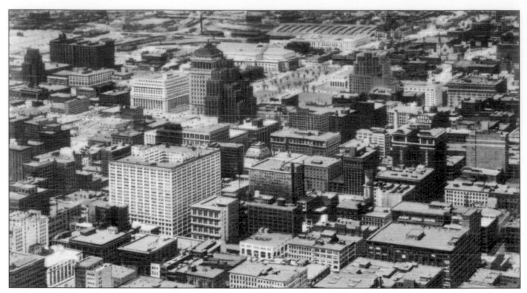

AIR VIEW OF DOWNTOWN. Captured sometime in the 1930s, this bird's eye perspective of downtown St. Louis shows a number of still-familiar landmarks. The large white building in the left foreground is the Railway Exchange Building that houses time-honored retailer Famous-Barr. Further back is the old Southwestern Bell headquarters, the Civil Court and Federal Court buildings, and the Union Station train sheds. To right-center, close inspection reveals the top of the old Statler Hotel on Washington (recently converted to the Renaissance St. Louis Grand).

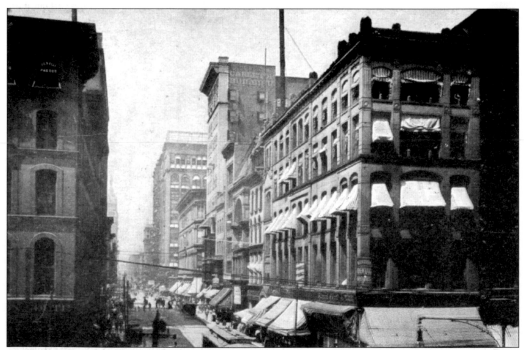

BROADWAY AND OLIVE. The streetcars, utility wires, window awnings, and pedestrian clothing styles shown in this scene vanished over the years. But some of the structures remain. Today's city workers, dwellers, and visitors scurry about their business on this same corner.

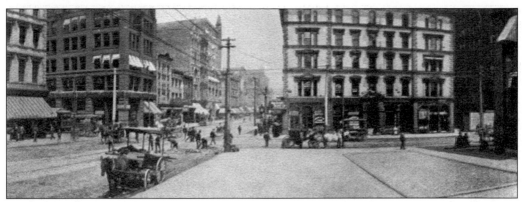

BROADWAY LOOKING NORTH FROM COURTHOUSE. Most of the buildings seen in this early photo no longer exist. Yet, the Old Courthouse and the area's heavy commerce persist. Looking from the same corner today, one can observe parking garages, a relatively new Bank of America building, the towering Metropolitan Square building and more. But, some vintage office buildings can still be seen in the distance.

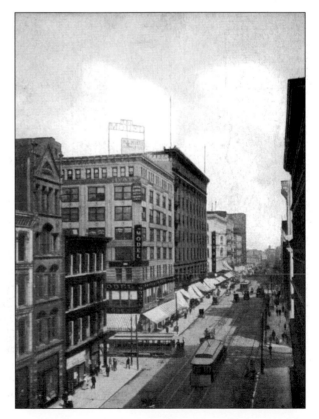

WASHINGTON LOOKING EAST FROM SEVENTH. From this viewpoint today, Washington appears quite different. Yet some of these buildings survived the onslaught of wrecking crews. And, after years of neglect, the street that began to resemble a ghost town found new life following the advent of the Convention Center. Today the area blossoms with newly revitalized hotels and other attractions.

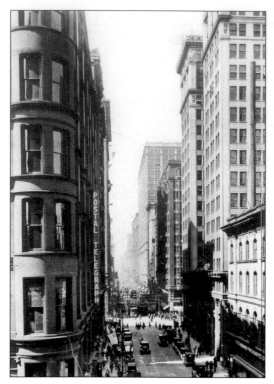

OLIVE STREET CANYON. Here people are bustling about, and vehicles lining the curbs are dwarfed by imposing downtown office buildings. For a perspective, the address of the Postal Telegraph Cable Company at front left was 408 Olive. Since the time of this photo shoot, some of these buildings have vanished.

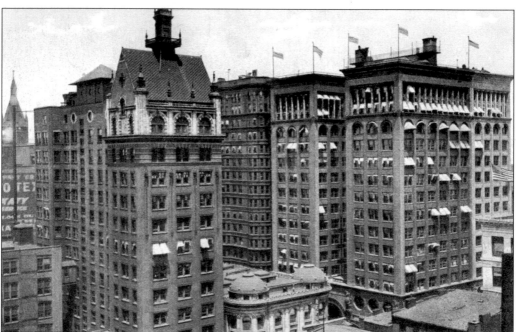

SKYSCRAPERS SEVENTH AND OLIVE. The front-right "skyscraper," seen almost in its entirety, is one of downtown's remaining treasures. Designed in 1892, the Union Trust Company building was once the tallest building in the city. Though falling prey to some face changes over the years, its basic appearance is still impressive. It continues to serve various business enterprises.

OLIVE WEST OF EIGHTH. The march of time has done little to alter the overall image of these buildings. Owing to the noble efforts of preservationists, grand edifices such as the Old Post Office, front-right, received the designation of City Landmark. Also named a National Historic Landmark in 1968, the Old Post Office (see page 6) continues to stir up controversy over its possible use.

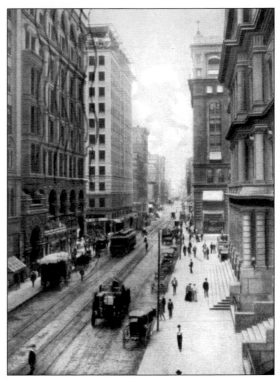

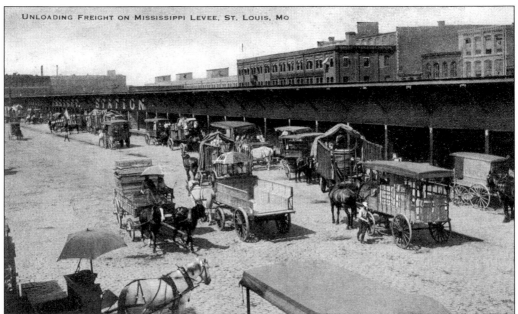

UNLOADING FREIGHT ON THE LEVEE. With St. Louis as a primary river port before other forms of transportation gained prominence, this levee scene was a common sight to St. Louis citizens of yore. Modern workers appreciate the advances brought by technology, but perhaps long to experience the days when wagons depended on real horsepower—no worry about the rising cost of gasoline.

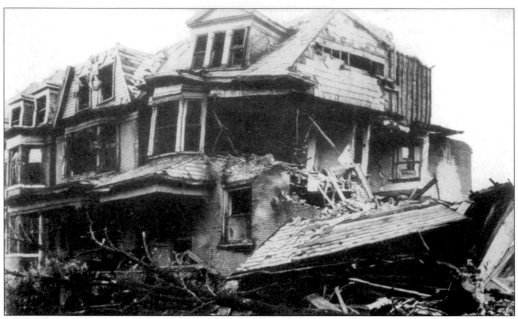

1927 Tornado Scene. Every St. Louis generation can recall one or more tornadoes creating havoc in some part of the city. The *St. Louis Post-Dispatch* report of the September 29, 1927 disaster tallied 86 people dead and 500 injured. This picture taken at 4201 Maryland is one of a series of photos taken of the devastation and used on postcards.

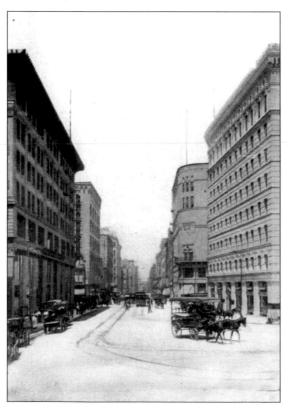

Washington Looking West From Third. This view is now blocked by a St. Louis Center pedestrian overpass. The second building on the left, at 400 Washington, was originally the J. Kennard and Sons Carpet Company building. Some may remember it as Edison Brothers. By mid-2003, its rebirth dubbed it a boutique hotel, the WS on Washington. Built around 1900, it predates the second Missouri Athletic Club building facing it on Washington.

**BROADWAY LOOKING
NORTH FROM OLIVE.**
Nineteenth century St. Louis
citizens would probably not
recognize this section of
Broadway. But from this
vantage point, modern-day
viewers can still see vestiges
of that era. Happily, the big-
city vitality seems to be
making a comeback.

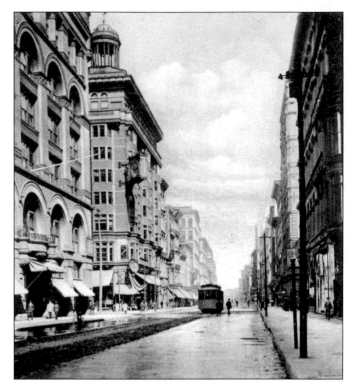

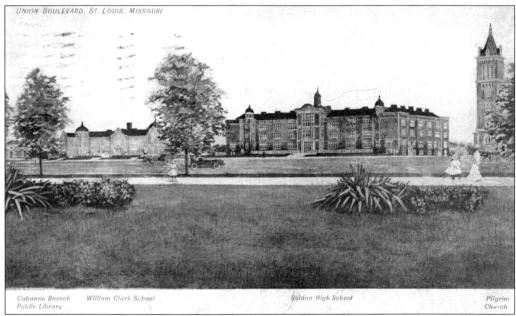

Cabanne Branch William Clark School Soldan High School Pilgrim
Public Library Church

UNION BOULEVARD. Standing testimony to the architectural wonders erected in St. Louis
during the first decade of the 20th century, these four buildings continue to serve the
purpose for which they were designed. The Cabanne Branch Library, William Clark
School, Soldan High School, and Pilgrim Congregational Church, seen in this vintage
rendering, still grace Union Boulevard.

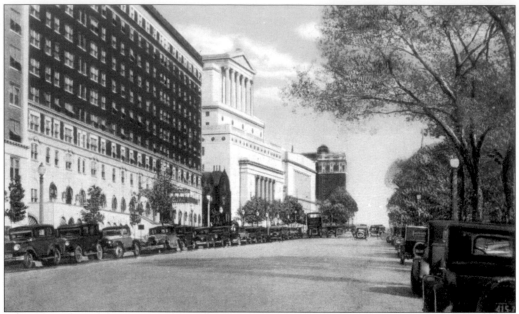

LINDELL BOULEVARD. This *c.* 1930s view looking east on Lindell Boulevard shows little change. Front to back is the Coronado Hotel (see page 52) , the home of a Mr. George Mackey (now gone), the Masonic Temple—the old Woolworth Building next door is out of view— the Scottish Rite Cathedral (see page 59), and the old Melbourne Hotel, now Jesuit Hall.

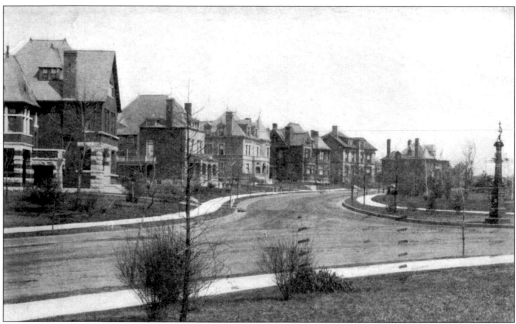

LONGFELLOW BOULEVARD. Entered from South Grand Avenue, this lovely street managed to survive urban decay with many of these stately 19th and early 20th century built homes intact. With the late 1900s trend toward restoration and preservation, this curving drive looks better than ever.

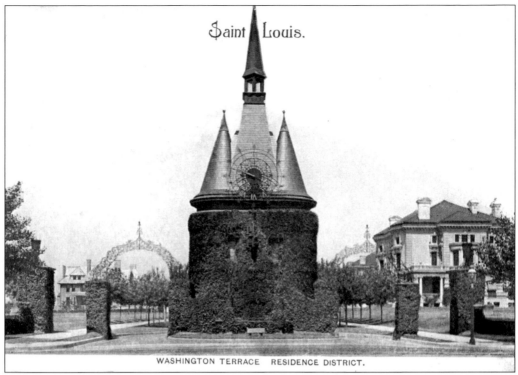

Saint Louis.

WASHINGTON TERRACE RESIDENCE DISTRICT.

WASHINGTON TERRACE RESIDENCE DISTRICT. Off Union Boulevard, and south of the vista shown on page 15, a number of exclusive residential places arose late in the 19th century. These Washington Terrace entrance gates, designed in 1893, allow current day travelers on Union a hint of the wealth that effected their construction. Existing mansions beyond the gates remain prestigious addresses.

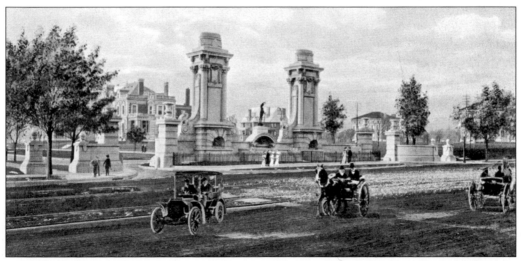

KINGSBURY PLACE. Near Washington Terrace, this magnificent Kingsbury Place gateway also faces Union. Some of St. Louis's wealthiest citizens built mansions on these private streets to escape the problems inherent with city living. Though no longer totally isolated from the city environment, Kingsbury Place continues to support a number of palatial residences.

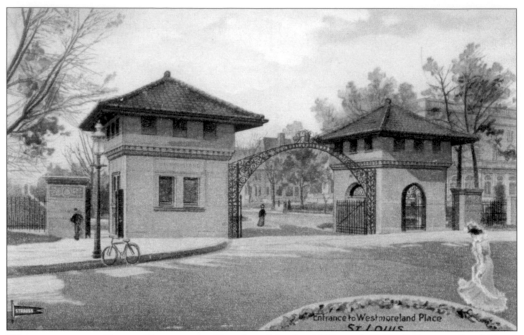

WESTMORELAND PLACE ENTRANCE. Developed in the 1880s and 1890s, Westmoreland Place, as well as Kingsbury Place, continue to maintain some of the oldest and most majestic homes in what is known as the Central West End. This gateway off Union looks much the same today.

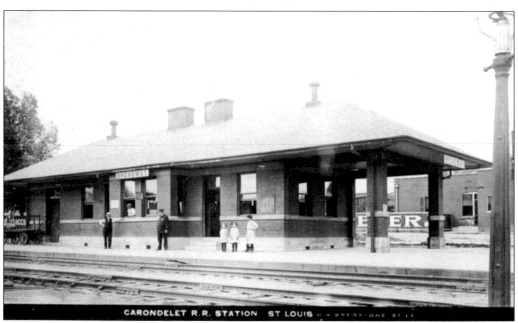

BROADWAY RAILWAY STATION. The photo on the postcard shows the train station once located at Broadway and Tesson in south St. Louis. The clothing styles of the people and the light fixture on the right provide an interesting glimpse into the past. Travelers on Broadway in this historic Carondelet neighborhood (see pages 79 and 80) still observe the railroad signal before crossing these same tracks.

Two

PUBLIC BUILDINGS

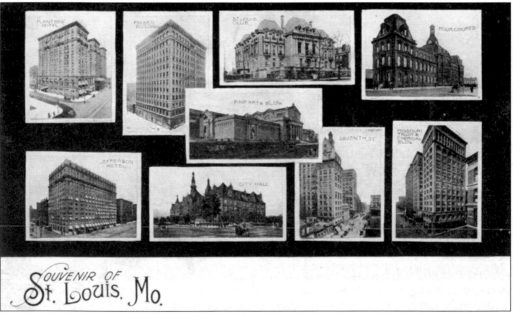

FRONT OF FOLDOUT SOUVENIR CARD. More than half of the buildings displayed on this souvenir card, printed around the time of the 1904 World's Fair, are still in use. They display a sampling of the various types of architecture that continue to enrich the St. Louis landscape.

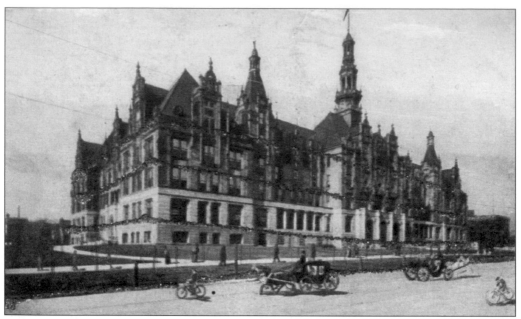

CITY HALL. Fashioned in Louis XIV architecture after the Hotel de Ville in Paris, France, St. Louis City Hall was dedicated in 1904. Lasting into the next century, it is solid enough to survive another. Some see it as grand, while others consider it ugly. Regardless, it is one of those reassuring symbols of stability.

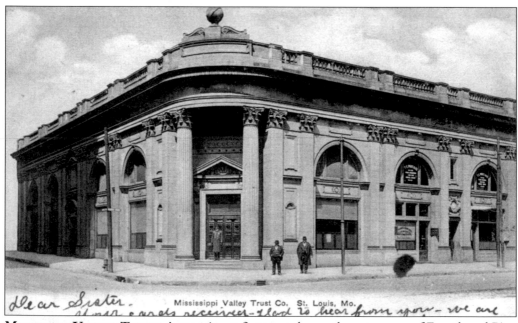

MISSISSIPPI VALLEY TRUST. A prominent fixture at the northwest corner of Fourth and Pine since 1896, the Mississippi Valley Trust Building retains most of its original appearance as seen in this vintage photo. The portly bankers standing in front are no longer part of the scenario. Though vacated sometime in the first half of the 20th century, various enterprises have used its prime space since.

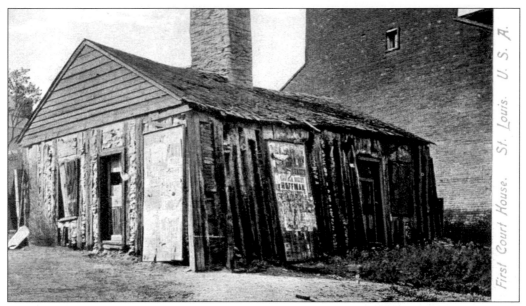

FIRST COURTHOUSE. This photo has been reproduced in a number of historical publications. It was reportedly St. Louis's first courthouse. Used from 1817 to 1820, it stood somewhere on Third Street.

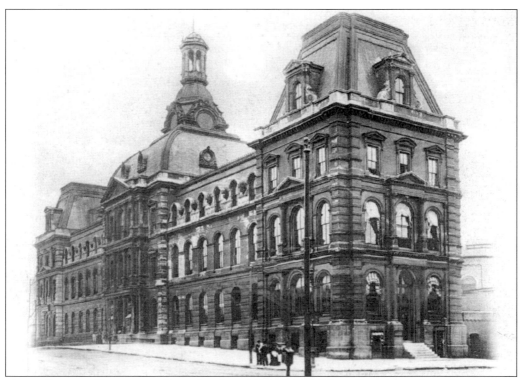

FOUR COURTS BUILDING. Completed in 1871, this building also pictured on the souvenir card on page 19, occupied the square bounded by Clark, Spruce, Eleventh, and Twelfth. The structure in that space is now a fire station.

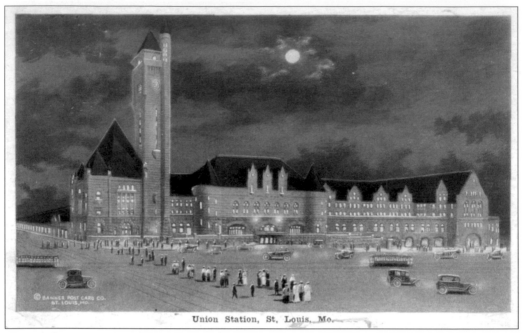

Union Station, St. Louis, Mo.

UNION STATION. At one time considered the largest railroad station in the world, Union Station opened in 1894. As cavernous and ornate on the interior as it is still breathtakingly striking on the exterior, it later fell into disrepair with the loss of passenger revenues. Finally, it was abandoned by the railroads. In the last half of the 20th century, visionaries spared it from destruction, converting it into a thriving hotel, shopping, and entertainment center.

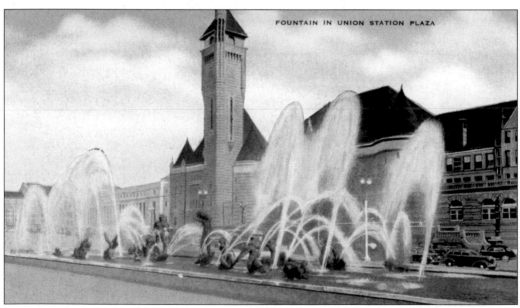

FOUNTAIN IN UNION STATION PLAZA

ALOE PLAZA FOUNTAIN. Symbolizing the wedding of the Mississippi and Missouri Rivers, this spectacular fountain featuring bronze nudes was dedicated on May 11, 1940. Replacing a burgeoning slum across Market from Union Station, the block where it is situated received the name Aloe Plaza after Louis P. Aloe, a notable St. Louis figure.

MISSOURI ATHLETIC CLUB. This 1914-designed building is the second at the same site to house the Missouri Athletic Association. Now, as then, its uniquely beautiful brick and mosaic tile exterior make it the jewel of Washington Avenue.

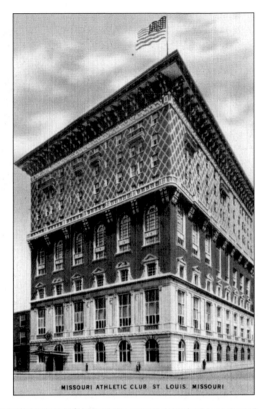

MISSOURI ATHLETIC CLUB. ST. LOUIS. MISSOURI

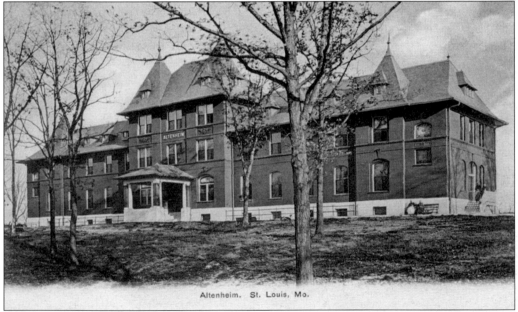

Altenheim. St. Louis, Mo.

ALTENHEIM. This Charles P. Chouteau mansion, on a bluff overlooking the Mississippi River, was purchased in 1901 by the German Altenheim Society to use as a facility to care for the aged. It was razed in 1972, and a new Altenheim was erected on the same grounds located in the Carondelet neighborhood.

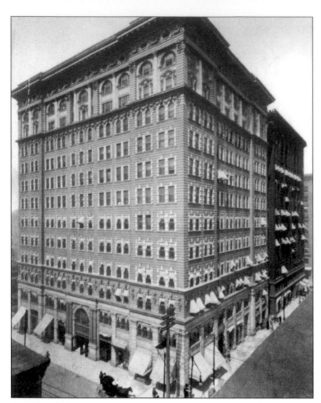

MISSOURI PACIFIC BUILDING.
The Missouri Pacific Building
predates the deco-gothic structure
on Olive that was built in the
1920s (see page 84).

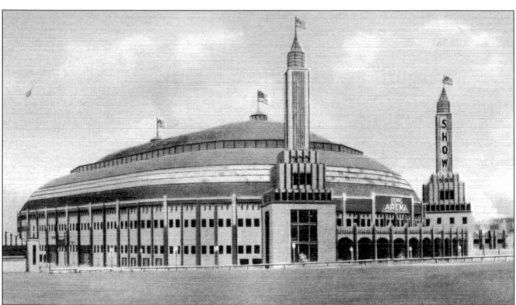

ARENA. The image of this 1920s domed structure, always called The Arena, will elicit fond
memories for generations of St. Louis residents. The back of this card boasts of its "seating
capacity of 21,000 . . . larger than Madison Square Gardens." Used for all types of exhibits and
sporting events over the years, it was finally imploded in 1999 after Blues Hockey moved to
the new Keil Center (now Savis) downtown. Hockey fans still grieve its loss.

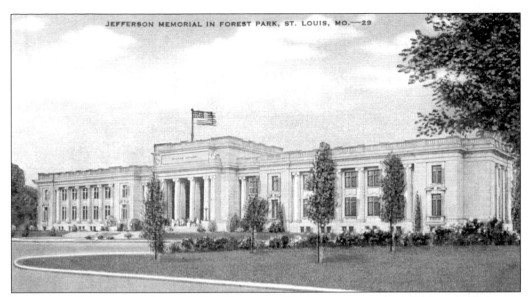

JEFFERSON MEMORIAL. Named for Thomas Jefferson, our nation's third president, this stately tribute dates back to 1911. Located at the site of the main entrance to the 1904 World's Fair, it houses a colossal marble statue of its namesake. Now called the Missouri History Museum, it is much larger due to a recently constructed addition that enhances both its appearance and possible use.

DEUTSCHES HOUS. Located in the historic Lafayette Square District, this building, constructed in 1928, appears the same to viewers on Lafayette at Jefferson Avenue to this day. Known to many as the German House, it is now the Gateway Christian School and Word of Life Ministries.

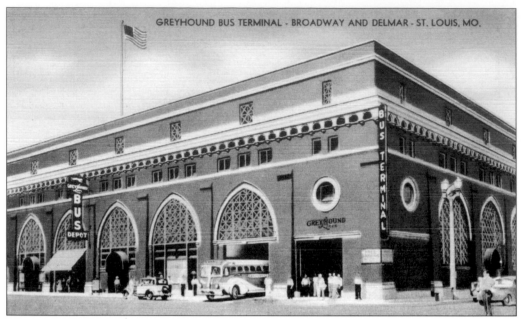

GREYHOUND BUS TERMINAL · BROADWAY AND DELMAR · ST. LOUIS, MO.

GREYHOUND BUS STATION. Football fans and other visitors to the relatively new Edward Jones Dome will recognize this nearby structure as the Drury Inn. Originally, it was built in the mid-1920s as the new Union Market Building. When the market lost business to modern grocery stores, part of it was used as a bus station about a decade later. Greyhound left it years ago, but it continued to arouse entrepreneurial interests.

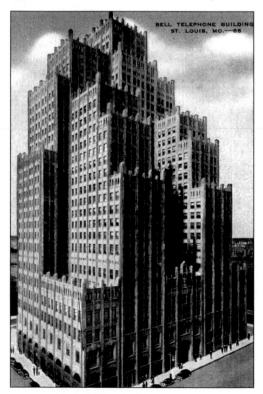

BELL TELEPHONE BUILDING
ST. LOUIS, MO.—65

SOUTHWESTERN BELL TELEPHONE BUILDING. Considered the tallest building in Missouri when it reached completion in 1926, this 31 story Art Deco "skyscraper" is commonly known to generations of telephone company employees as "1010 Pine," the building's address. Once the headquarters of Southwestern Bell Telephone, it is now overshadowed by the much newer SBC Building next door.

Three
BRIDGES, BOATS, AND WATER TOWERS

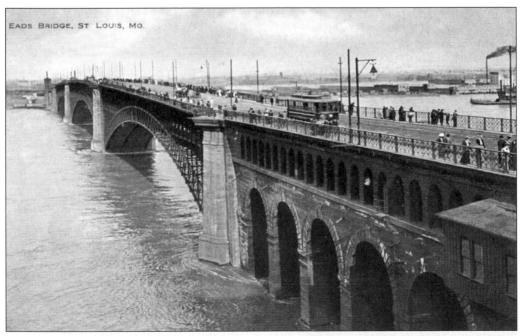

EADS BRIDGE, ST LOUIS, MO.

EADS BRIDGE. Almost eight years in the making, with every possible obstacle impeding progress, this span over the Mississippi was first dedicated on Independence Day, 1874. To this day considered a triumph of engineering skill, the double-decked Eads Bridge accommodated train, vehicle, and pedestrian traffic. Closed for repairs over a century later, it reopened in grand style on July 4, 2003.

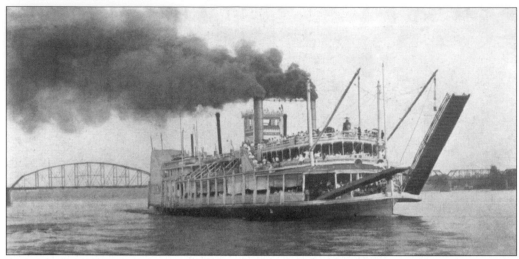

CITY OF PROVIDENCE. Captain William H. Thorwegian owned this and a number of other steamboats that traveled the Mississippi during their heyday. Fire and ice were the main enemies of these elegant boats. Ice claimed the City of Providence at St. Louis in 1910.

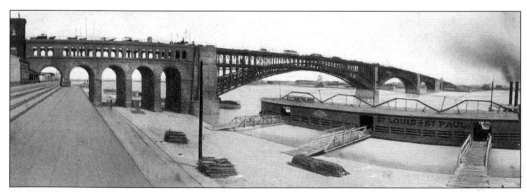

DIAMOND JO. This photo postcard offers a panoramic view of the Eads Bridge. The name Diamond Jo in the card's description of the wharf boat is the name of a boat line purchased by Captain John Streckfus in 1911.

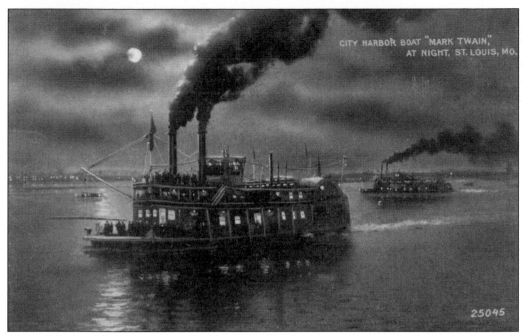

MARK TWAIN. The romance and adventure of cruising steamboats seen from the St. Louis riverbank is lost in antiquity. This night scene featuring the Mark Twain captures an idyllic image of St. Louis history.

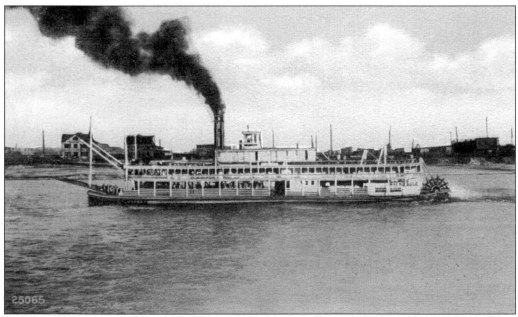

EXCURSION BOAT. Close inspection reveals that this is the excursion boat Bald Eagle. The tower in the left background appears to be one of the water towers in Hyde Park (see page 34).

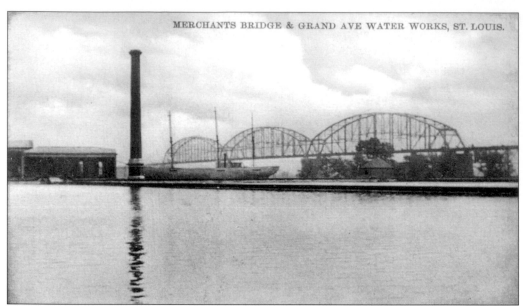

MERCHANTS BRIDGE AND GRAND AVENUE WATER WORKS. An old railroad crossing near the McKinley Bridge further south, this bridge and the water works in the photo are still in use.

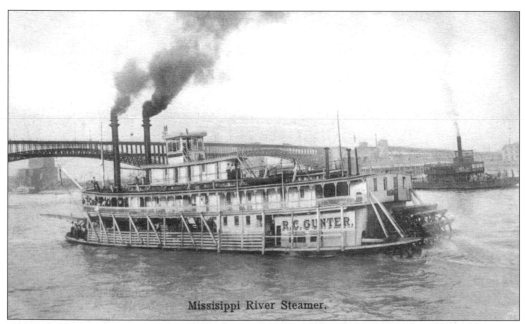

Missisippi River Steamer.

MISSISSIPPI STEAMER R.C. GUNTER. This steamer, the R.C. Gunter, was operated by the St. Louis, Harden, and Hempsville Packet Company around 1896. After running excursions from Kansas City beginning in 1902, it was finally dismantled in St. Louis later that decade.

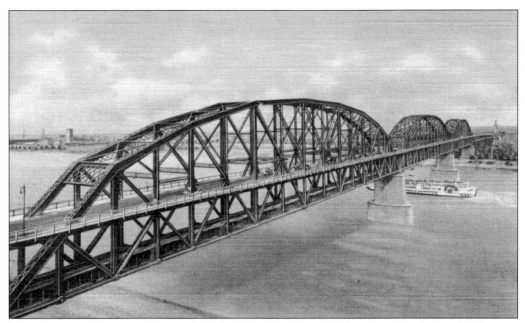

MAC ARTHUR BRIDGE. Once called the Municipal Free Bridge, the Mac Arthur Bridge can be seen near Fourth and Chouteau, close to downtown. No longer in use, it was once described as the "largest double span steel bridge in the world."

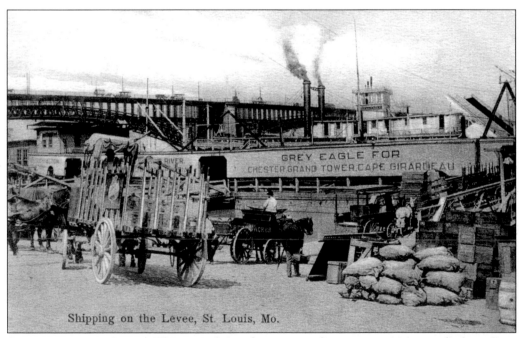

Shipping on the Levee, St. Louis, Mo.

SHIPPING ON THE LEVEE. This typical riverfront scene of a century ago, names the boat Grey Eagle, an excursion boat eventually destroyed by an ice jam in Paducah, Kentucky.

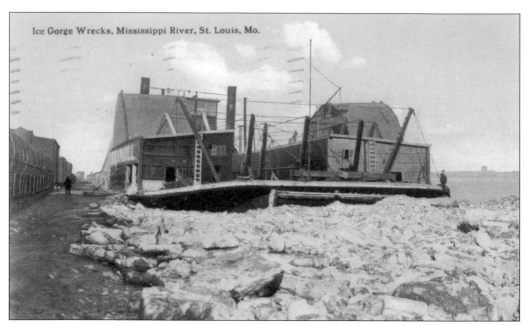

Ice Gorge Wrecks, Mississippi River, St. Louis, Mo.

ICE GORGE ON THE MISSISSIPPI. This photo demonstrates the wreckage to boats caused by ice.

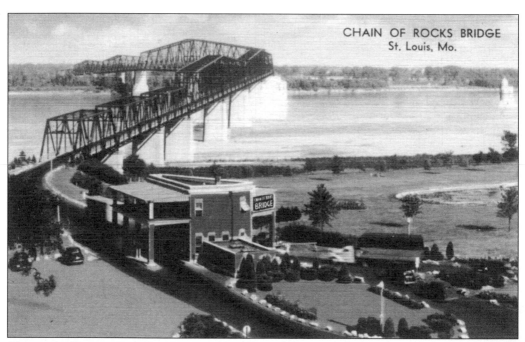

CHAIN OF ROCKS BRIDGE
St. Louis, Mo.

CHAIN OF ROCKS BRIDGE. Just south of the confluence of the Missouri and Mississippi Rivers, the picturesque Chain of Rocks Bridge was built in 1929. The 22 degree bend in this once thriving toll bridge was the solution to an engineering issue. Closed in 1967 after the nearby Interstate 270 bridge was completed, it fell into disrepair and disrepute. But, it received new life in 1999 when its proponents funded its reopening for bicycle and pedestrian use.

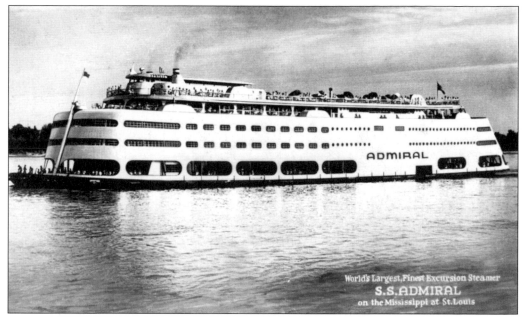

World's Largest, Finest Excursion Steamer
S.S. ADMIRAL
on the Mississippi at St. Louis

EXCURSION STEAMER *ADMIRAL*. Scores of St. Louis natives happily recall day trips and evening dinner-dance cruises on the *Admiral*. Dressing up in your finest drew comments like, "You must be goin' on the boat!" Built in 1907, "the boat" became the *Admiral* in 1940. Now docked, it is the President Casino.

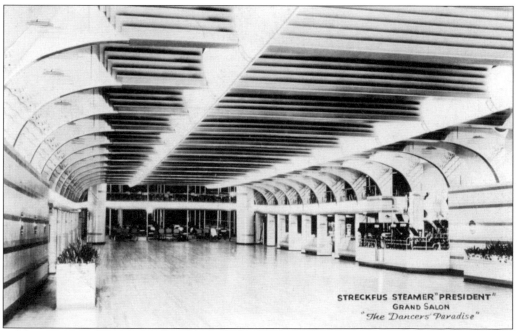

STRECKFUS STEAMER "PRESIDENT"
GRAND SALON
"The Dancers' Paradise"

STRECKFUS STEAMER GRAND SALON. The Streckfus Line, named for Captain John Streckfus, is associated with excursions and good music. The inside view of this boat, the President, reveals a large dance floor. Some historians claim that the word "jazz" is derived from the Streckfus steamer *JS*, named for the captain.

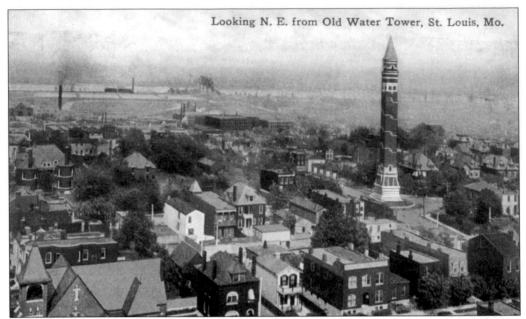

Looking N. E. from Old Water Tower, St. Louis, Mo.

BISSELL STREET WATER TOWER LOOKING NORTHEAST. This is one of three surviving Victorian-era water towers in St. Louis. It retains its majesty today, thanks to a 1970s restoration. Dating to the mid-1880s, it can be seen from the Mississippi River. This early 20th century view avails a good concept of the surrounding Hyde Park neighborhood. In the upper left, by the river, there appears to be a baseball diamond!

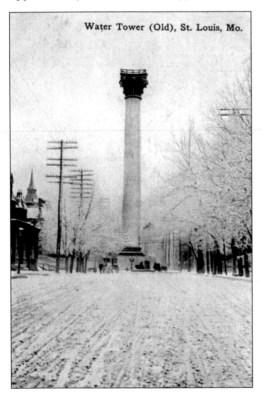

Water Tower (Old), St. Louis, Mo.

OLD WATER TOWER. The oldest of the two Hyde Park water towers, this white 154-foot Corinthian column dominates the center of East Grand Avenue. Constructed in 1871, it was retired from service some ninety years ago. Along with the Bissell Street Tower, this City Landmark is listed on the National Register of Historic Places.

34

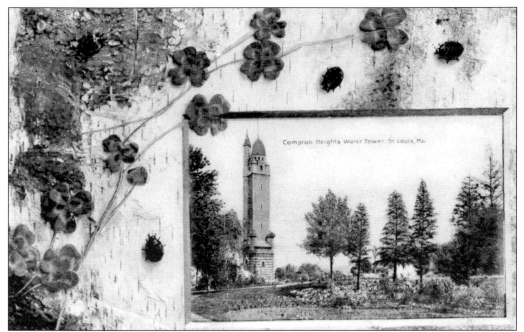

COMPTON HEIGHTS WATER TOWER. Also listed on the National Register, the Compton Hill Water Tower is the third remaining water tower in St. Louis. Regulating water pressure to the neighborhood from 1899 until 1929, it is located in the Compton Hill Reservoir Park on South Grand. Recent restoration returned the water tower to its original glory, and its 179-foot height gives it reign over the landscape.

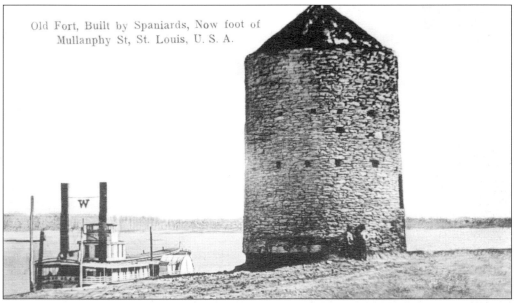

OLD SPANISH FORT. Known as Roy's Tower, this was one of several forts built by the Spanish to defend St. Louis from the English during the American Revolution. Later acquired by a man named Jean Baptiste Roy, it was then used as a windmill. The ancient stone edifice at the foot of either Mullanphy or Biddle was demolished in 1860.

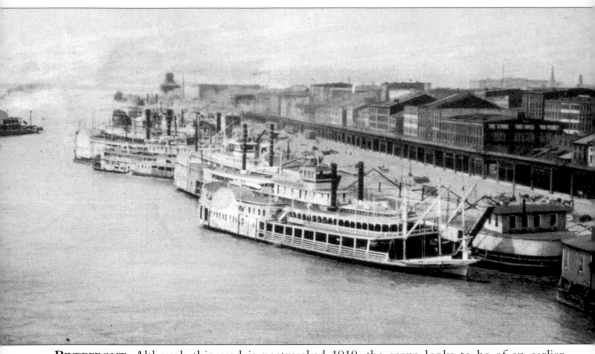

RIVERFRONT. Although this card is postmarked 1910, the scene looks to be of an earlier period. It does provide a picture of the St. Louis riverfront when boats lined up like our vehicles now pack parking lots.

Four
COMMERCE

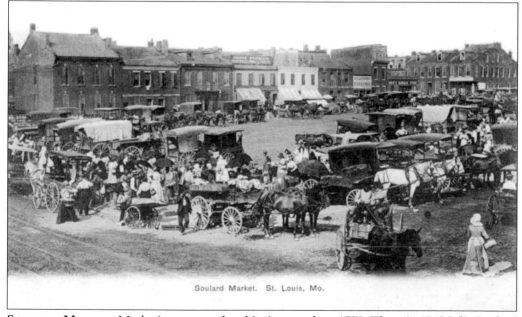

Soulard Market. St. Louis, Mo.

SOULARD MARKET. Marketing occurred at this site as early as 1779. Then, in 1842 Julia Soulard donated these grounds to the City to be used as a public market. Today's throngs of buyers and sellers conduct business inside the noble Italian 1920s-built market building on the same property. Located in a historic and eclectic neighborhood, it shows no sign of ever closing.

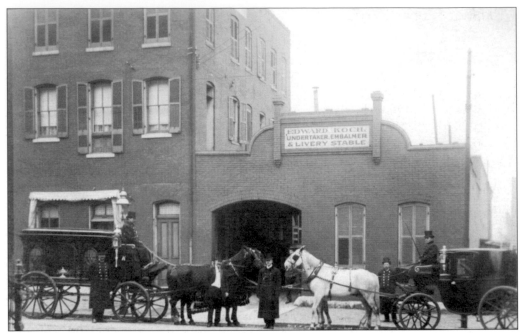

EDWARD KOCH UNDERTAKER, EMBALMER AND LIVERY STABLE. Mr. Koch's establishment was located at 3516 North Fourteenth Street. This photo is a vivid depiction of the days when horse driven hearses were common.

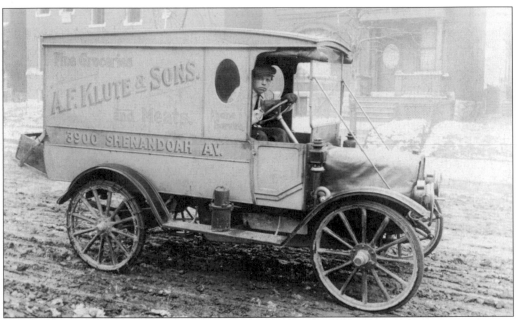

A.F. KLUTE AND SONS FINE GROCERS. Every detail in this amazing image of early 20th century life in St. Louis tells much about the times. In addition to the name and address of the store, the signage on the truck boasts "Phone Service." The red brick building at 3900 Shenandoah is still in use, but not by a grocer. On a corner like so many corner stores of yesterday, it looks amazingly new.

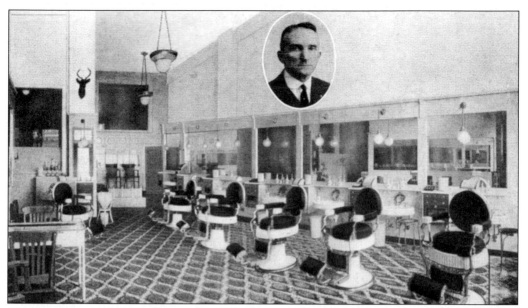

METROPOLITAN BARBER SHOP. Many St. Louis natives and long time residents remember going to this shop for a hair cut. Located at Grand and Olive, it was one of numerous businesses of its kind in the metropolitan area. There are still some around.

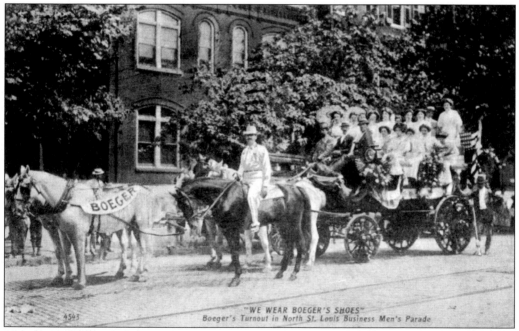

"WE WEAR BOEGER'S SHOES"
Boeger's Turnout in North St. Louis Business Men's Parade

4543

BUSINESS MEN'S PARADE. Postmarked 1909, this card was used as an advertisement for Boeger Shoe Company, which was located at 2508 North Fourteenth. The photo shows the company's participation in the North St. Louis Business Parade.

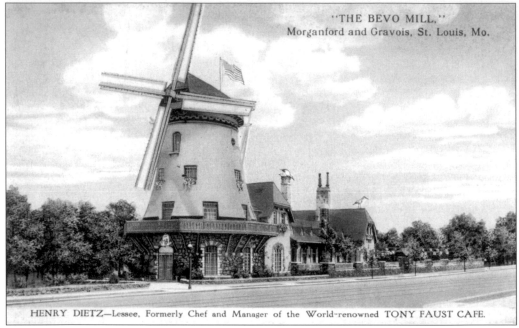

"THE BEVO MILL,"
Morganford and Gravois, St. Louis, Mo.

HENRY DIETZ—Lessee, Formerly Chef and Manager of the World-renowned TONY FAUST CAFE.

BEVO MILL. Named for the Anheuser-Busch Prohibition product (see page 43), the Bevo Mill restaurant opened in 1916. Providing the funds for its erection, local beer baron Adolphus Busch wanted to show that a good restaurant could survive without serving alcohol if it had good food. Built with a huge Dutch windmill at its entrance, it became a south St. Louis landmark. Though no longer owned by the Busch family, it operates as a restaurant even today.

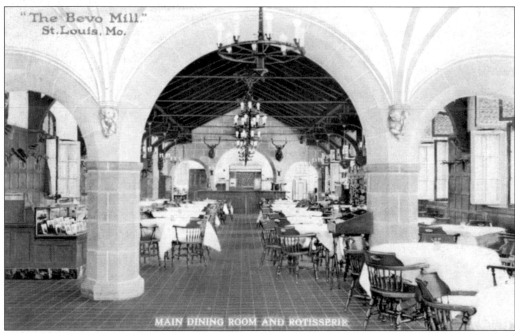

"The Bevo Mill."
St. Louis, Mo.

MAIN DINING ROOM AND ROTISSERIE

MAIN DINING ROOM AND ROTISSERIE. The main dining room at the Bevo Mill still maintains the old world charm as seen in this vintage photo.

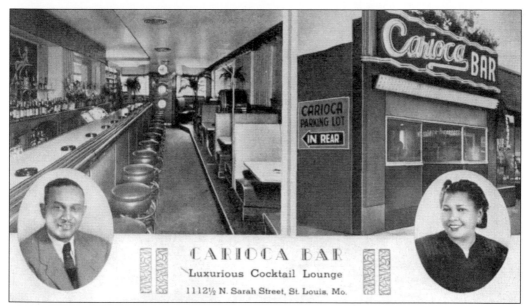

CARIOCA BAR.
Luxurious Cocktail Lounge
1112½ N. Sarah Street, St. Louis, Mo.

CARIOCA BAR. In the past, some of St. Louis's well-known eating and drinking establishments used postcards such as this to promote business. Both exterior and interior views, as well as photo-portraits of the owners, enticed patronage.

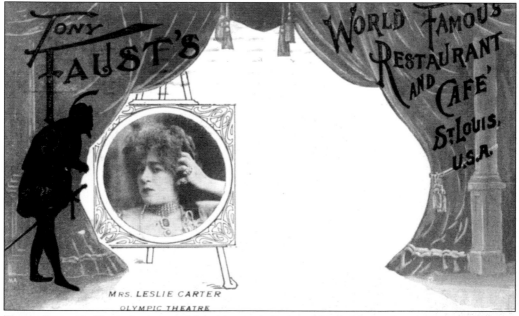

MRS. LESLIE CARTER
OLYMPIC THEATRE

TONY FAUST'S RESTAURANT. Celebrities and distinguished citizens frequented the famous Tony Faust Restaurant. A Prussian immigrant, Faust opened his first establishment at Broadway and Chouteau. Moving to larger quarters on Broadway and Elm in 1871, the restaurant lasted until 1916 when the area stopped drawing patrons. The Olympic Theatre advertised on this card closed that same year.

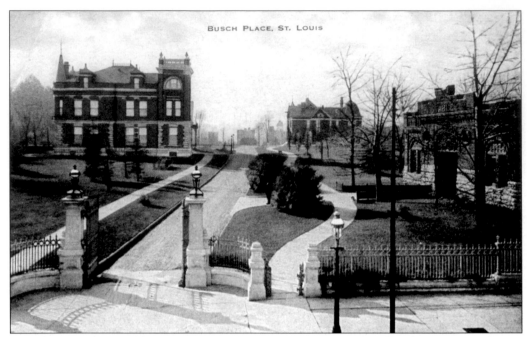

BUSCH PLACE. At the home of world-famous Anheuser-Busch Brewery, the street named Busch Place now curves past the giant beer maker's newer headquarters. The building on the right was a stable.

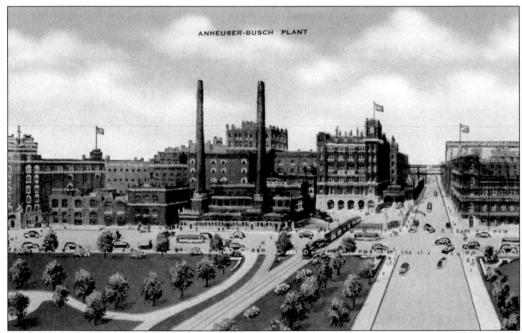

ANHEUSER-BUSCH PLANT

ANHEUSER-BUSCH PLANT. As business grew, the plant spread, making it a major employer and benefactor to the city of St. Louis. This *c.* 1940s depiction shows a number of the original red brick buildings still in use at the plant. It has operated as the Anheuser-Busch Brewery since 1873.

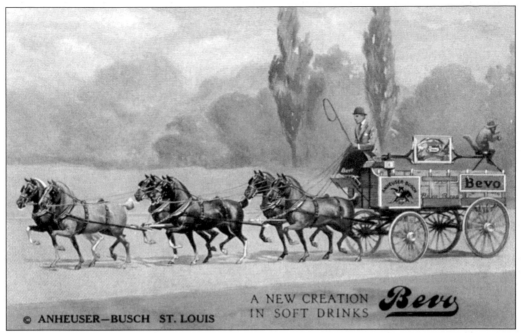

A NEW CREATION
IN SOFT DRINKS *Bevo*

ANHEUSER-BUSCH BEVO AD. The Bohemian word for beer, pivo, gave rise to the name for the non-alcoholic beverage Bevo. Concocted to taste like beer and save the brewery during the Prohibition era, it was a popular American drink at the time.

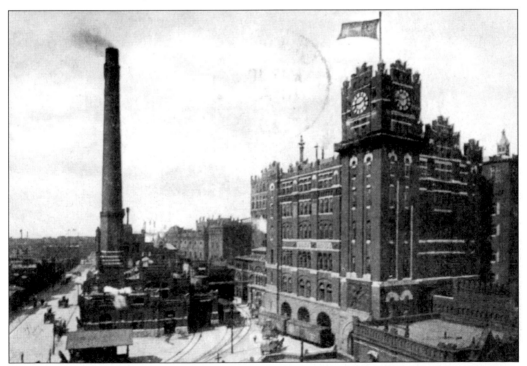

POWER PLANT AND BREW HOUSE. This is an early view of the Anheuser-Busch power plant and brew house.

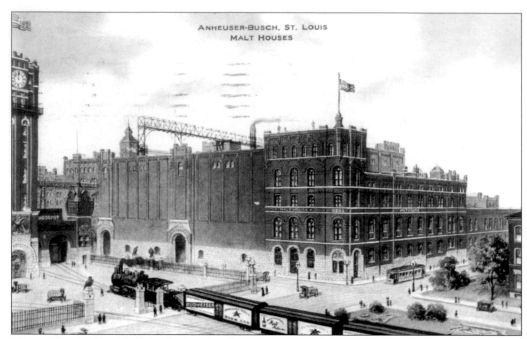

MALT HOUSE. In this busy city scene, the importance of the brewery to the local economy is clearly represented. The familiar brand name Budweiser, which first surfaced in 1876, is displayed on the rail cars.

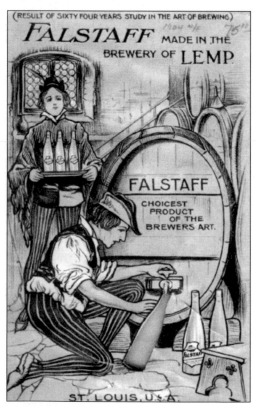

1904 FALSTAFF BEER AD WITH SAND ENCLOSED. "Choicest Product of the Brewers Art" is the slogan for Falstaff Beer. Brewed by Lemp, another large local beer maker at one time, it eventually ceased production in St. Louis.

REVERSE SIDE OF FALSTAFF AD WITH SAND. This is the reverse side of the postcard ad shown on the opposite page. Two cards sealed together at the edges concealed sand. When the card was turned upside down, and then back again, the sand was seen running through a clear cover on the beer bottle, creating the appearance of a man chugging beer.

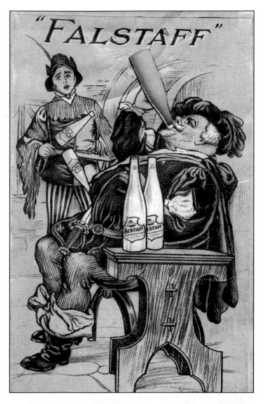

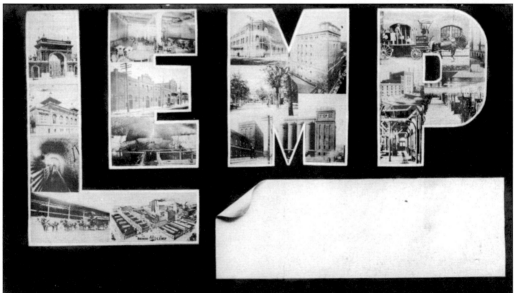

LEMP BREWERY SOUVENIR CARD WITH VIEWS. This view card shows the magnitude of the vast Lemp Brewery mentioned on page 44. Some of these buildings can still be seen from Highway 55, along with the famed Lemp Mansion. Purported to be haunted by the ghosts of ill-fated Lemp family members who owned the concern, the immense home now serves as a popular restaurant, dinner theatre, and bed and breakfast.

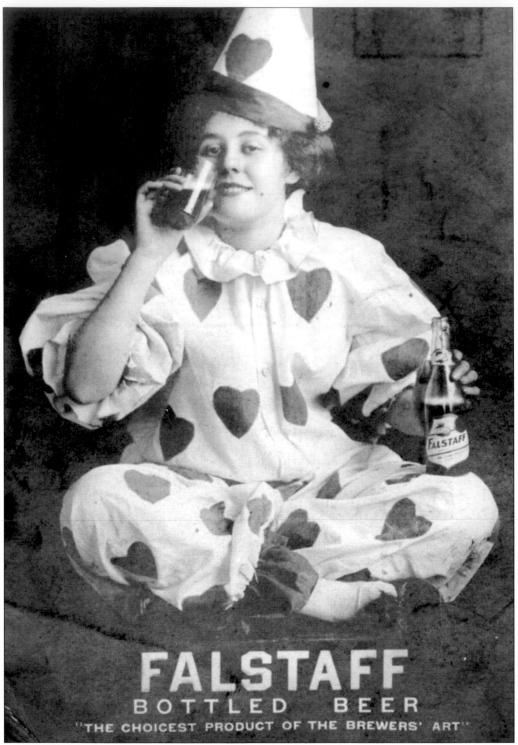

FALSTAFF CLOWN. A fine example of great advertising art used on postcards, this vintage 1900s Falstaff promotion challenges all of today's marketing ideas.

Five

HOTELS

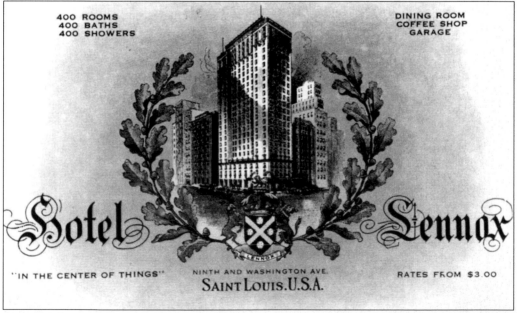

400 ROOMS
400 BATHS
400 SHOWERS

DINING ROOM
COFFEE SHOP
GARAGE

Hotel Lennox

"IN THE CENTER OF THINGS"

NINTH AND WASHINGTON AVE.
SAINT LOUIS. U.S.A.

RATES FROM $3.00

LENNOX HOTEL. Once again "in the center of things," the lofty Lennox survived the Great Depression and two failed efforts at revival. Touted as the city's tallest hotel when it opened in 1929, its latest rebirth in 2002 made it the Renaissance St. Louis Suites Hotel. And now, things are booming on Washington Avenue!

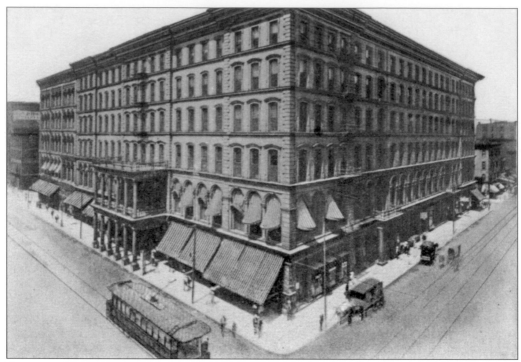

LINDELL HOTEL. Mentioned frequently in old accounts of St. Louis history, the Lindell was one of the city's chief hotels during the late 1800s. After the first one burned in 1867, a new, more elaborate Lindell opened at the same location in 1874. Progress eventually caused its demise, and its address on Washington between Sixth and Seventh is prime today.

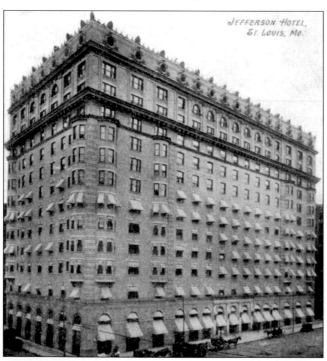

JEFFERSON HOTEL. Promoted as the "New Hotel Jefferson—The Aristocrat of St. Louis," when it opened in 1904 for the Fair, countless St. Louisans remember it as the Jefferson Sheraton where they attended social events in its elegant ballroom. By 2003, this grand hotel on Twelfth (now called Tucker) became the New Jefferson Arms used for adult and corporate housing. It is one more example of how the city's precious resources can adapt and prosper.

MARQUETTE HOTEL. Eventually replaced by a parking lot, the Marquette was built in 1906. Tony Faust Jr., son of the locally famous restaurateur (see page 41), managed the kitchen in this prominent hotel.

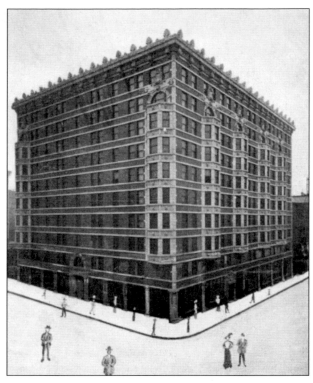

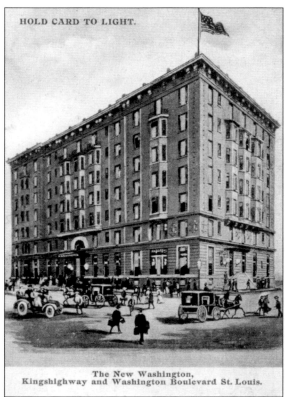

The New Washington,
Kingshighway and Washington Boulevard St. Louis.

THE NEW WASHINGTON HOTEL. Built in anticipation of the 1904 World's Fair, this seven-story hotel at Kingshighway and Washington is now the Washington Apartments. This is one of dozens of multi-layered cards, die cut at the windows or other places to lend realism when held to the light.

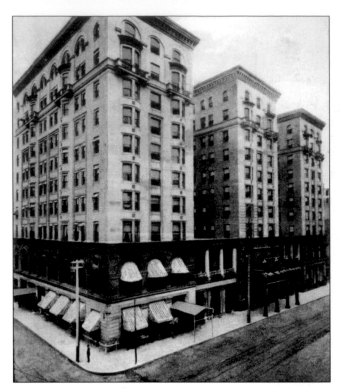

PLANTERS HOTEL. Completed in 1841, the Planters was the city's first truly grand hotel. Celebrated guests included names such as Charles Dickens and John James Audubon. It stood on the grounds extending from Chestnut to Pine on Fourth Street.

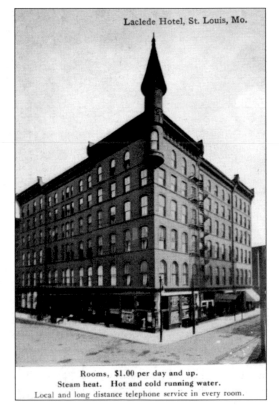

Laclede Hotel, St. Louis, Mo.

Rooms, $1.00 per day and up.
Steam heat. Hot and cold running water.
Local and long distance telephone service in every room.

LACLEDE HOTEL. The University of Missouri St. Louis Web site notes that the Laclede was "famous for serving riverboat and rail travelers, and was an important meeting place for the Missouri Democratic Party." Built sometime in the 19th century, it lasted until 1961 when it was demolished to allow space for Kiener Plaza.

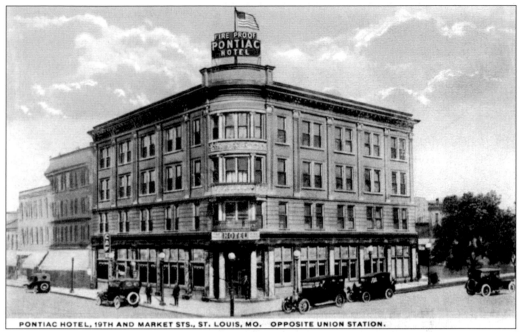

PONTIAC HOTEL, 19TH AND MARKET STS., ST. LOUIS, MO. OPPOSITE UNION STATION.

PONTIAC HOTEL. This hotel "opposite Union Station" must have been up-to-date when it first opened—note the "Fire Proof" sign on top. Now gone, it most likely deteriorated and became one of the eyesores razed with the planning of Aloe Plaza (see page 22).

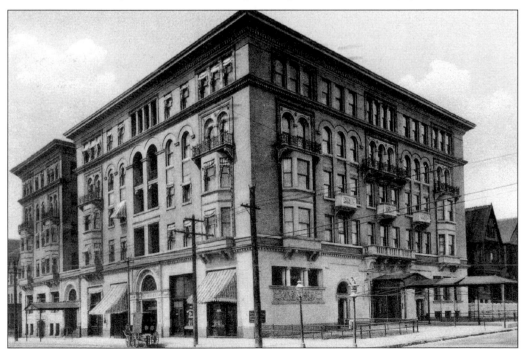

WEST END HOTEL. This small, attractive hotel at 939 North Vandeventer had balconies with ornate iron rails. The building was eventually destroyed, and today a single-story commercial structure fills some of its vacated space.

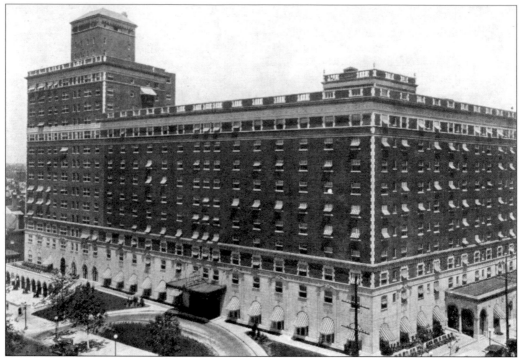

CORONADO HOTEL. First opened in the 1920s, the Coronado is one of the impressive constants that still line Lindell Boulevard (see page 16). At this writing, the time-honored structure is part of the Grand Center redevelopment plan. Soon it will reopen with apartments and lofts for university students and faculty.

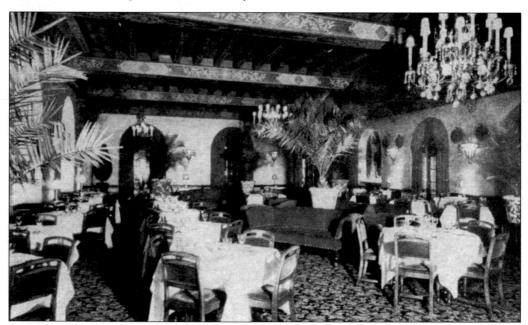

SPANISH GRILL IN THE CORONADO. This companion postcard to the one above reveals the elaborate Spanish Grill dining room in the old Coronado.

AMERICAN HOTEL. No visible trace of this hotel remains at Seventh and Olive Streets. The vertical sign above the front American sign reads "Vaudeville." What a deal to get a room for $1, and with a bath too!

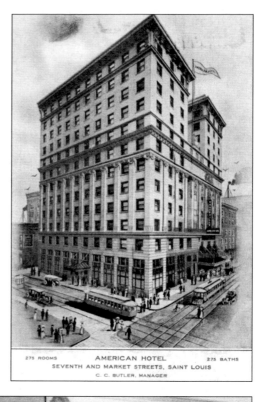

HOTEL ROOSEVELT. Located at 4903 Delmar at Laclede, this hotel building is now the Roosevelt Town Apartments. Its outward appearance has changed little over the years. Judging from this card, its modernistic "Wonder Bar," shown at right-bottom, surely caught the imagination of hotel guests!

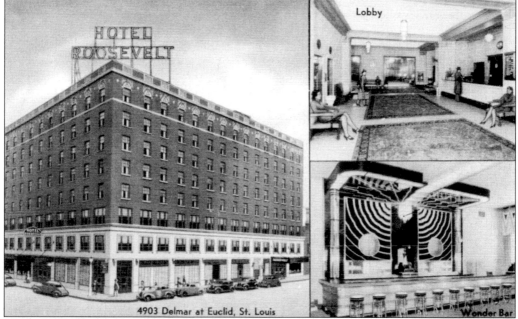

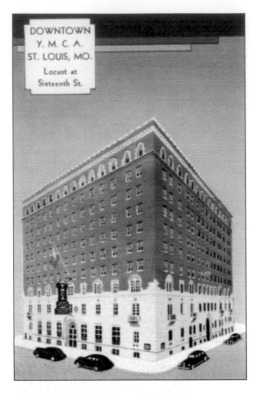

YMCA. It probably was "fun to stay at" this YMCA when it was built in 1926. Although St. Louis Ys are no longer residential, they continue to thrive in the metro area with fitness and family programs. This building continues as the Downtown Y, and doubles as the St. Louis area YMCA Headquarters.

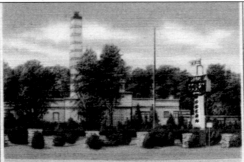

CORAL COURT
Ultra-Modern
One of the finest
in the Mid-West
on U. S. Highway 66
City Route, one mile
west of City Limits,
three miles east of
intersection of By Pass,
Highways #61, 66, 67
and 77

70 rooms, tile cottages
with private tile bath
in each room.
Hot and cold water
porter and maid service
—Beauty Rest Spring
and mattresses—
Hot Water Radiant
Heat—24 Hour Service
7755 Watson Road
(Highway 66)
St. Louis 19, Mo.

CORAL COURT. The now-legendary "No Tell Motel with a touch of class" opened in the 1940s. Its curvilinear yellow brick cabins with glass block windows enamored Route 66 travelers until its destruction in 1995 (it was replaced by a new subdivision). This postcard shows its first front sign. All that remains of Coral Court is one of its bungalows and the stone entranceway. The bungalow is now on display at the Museum of Transportation in St. Louis County.

Six
CHURCHES AND
HOSPITALS

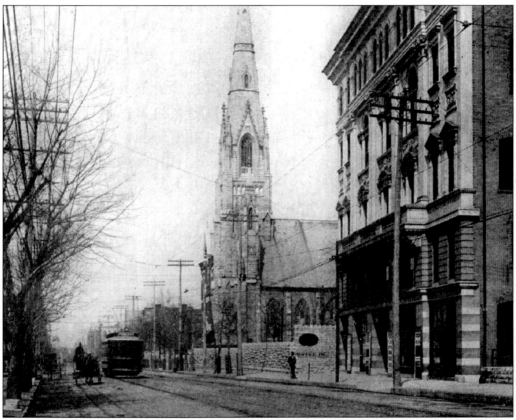

GRAND AVENUE ROCK CHURCH AND ODEON. Now called St. Alphonsus Rock Church, this limestone testament to endurance originated in the late 1860s. Serving the needs of the ever-changing community since then, it is more than a landmark on North Grand Avenue. The building in the forefront of this streetcar era photo is the Odeon, a music hall destroyed by fire some time ago.

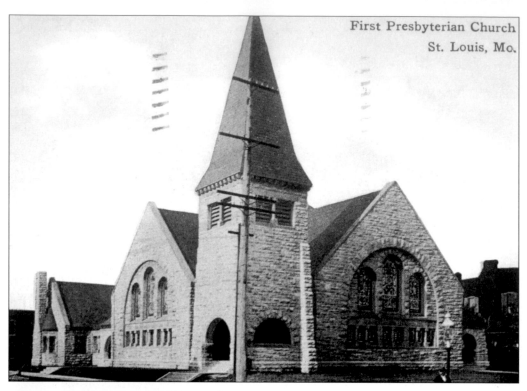

First Presbyterian Church
St. Louis, Mo.

(*above*) **FIRST PRESBYTERIAN CHURCH.** This stone church at Sarah and Washington was the third location for the 1817-established First Presbyterian Church in St. Louis. It served that congregation from 1888 until 1926. Since then it has been home to the Shiloh Temple Church of God in Christ. A good example of the stamina of such churches, its original bell and organ pipes are still in use. When the Presbyterians moved, they met at the Tivoli Theater until their current church on Delmar in University City was ready.

(*left*) **OLD CATHEDRAL.** One of St. Louis's most historically significant houses of worship, this church by the landing was consecrated in 1834. In 1961 it gained the title Basilica of St. Louis, King of France. Now it attracts tourists as well as worshipers.

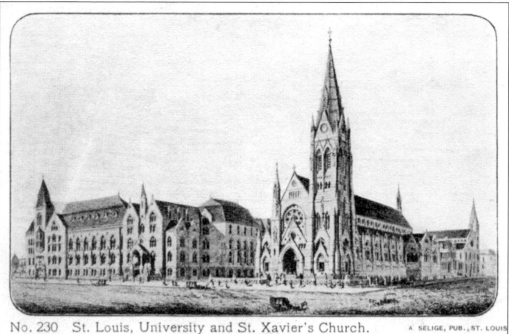

No. 230 St. Louis, University and St. Xavier's Church. A. SELIGE, PUB., ST. LOUIS

ST. FRANCIS XAVIER CHURCH. Known locally as "the College Church," St. Francis Xavier at Grand and Lindell opened its doors in the mid-1880s. Emil Frei of St. Louis, still a widely eminent maker of stained glass, designed its windows. St. Louis University staff and students, as well as area residents, worship here.

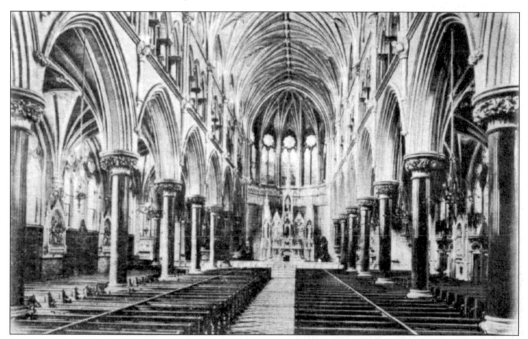

INTERIOR OF ST. FRANCIS XAVIER. This image displays the magnificent interior Gothic arches of the College Church shown above. The pipe organ has since been removed.

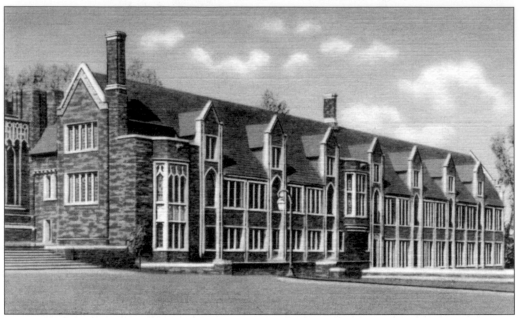

CONCORDIA SEMINARY. Although its Concordia Seminary lies just beyond the city limits in St. Louis County, the Lutheran Church-Missouri Synod has a large St. Louis presence. Its headquarters are also in the county, but Concordia Publishing, the denomination's official publishing house, continues to operate from its St. Louis home on Jefferson Avenue. Area residents of all religious persuasions tune into the Synod's radio stations KFUO-AM and FM. The latter is known as "Classic 99."

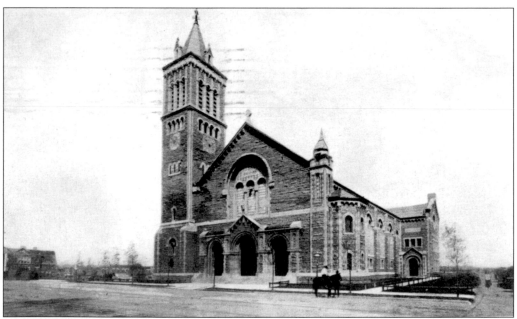

PILGRIM CONGREGATIONAL CHURCH. Gracing Union Boulevard since 1907 (see page 15) this house of god shows no sign of deterioration. It is one of St. Louis's many wonderful churches continuing to serve into the 21st century.

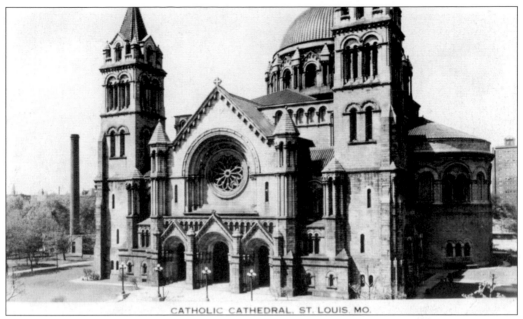

CATHOLIC CATHEDRAL, ST. LOUIS, MO.

CATHOLIC CATHEDRAL. In 1926, some nineteen years following its official ground-breaking, the New Cathedral of St. Louis was solemnly consecrated by Archbishop John Glennon. Its majestic presence has commanded the 4400 block of Lindell Boulevard ever since.

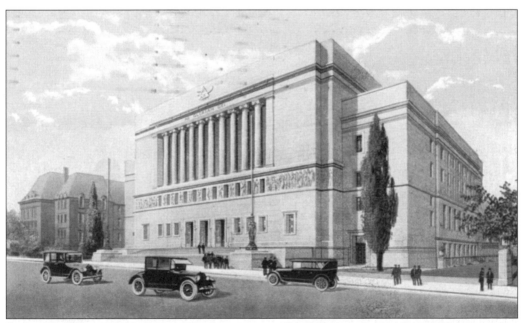

SCOTTISH RITE CATHEDRAL. Further east on Lindell (see page 16) another imposing structure, the Scottish Rite Cathedral, was built in 1924. Seen to the left on this picture is the long-gone George Mackey home mentioned on page 16. The Scottish Rite, a Masonic organization, has strong involvement in the Grand Center redevelopment.

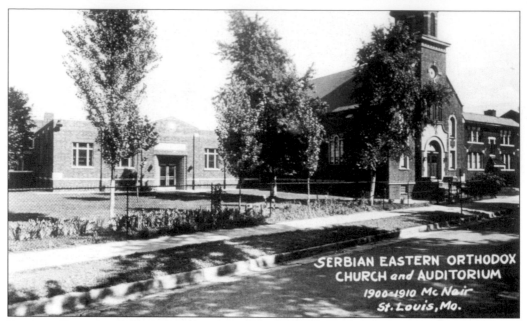

SERBIAN EASTERN ORTHODOX CHURCH. Now called the Serbian Eastern Orthodox Church Holy Trinity, this church on McNair, near McKinley High School, was built in 1928. The auditorium in the rear was added later.

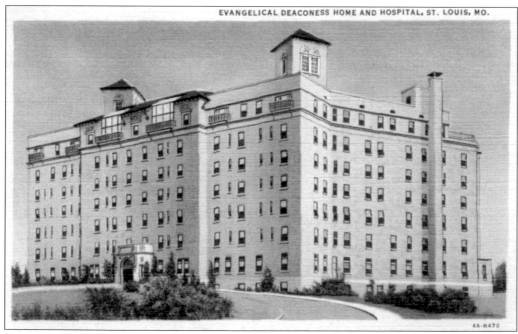

DEACONESS HOSPITAL. Now called Forest Park Hospital, this institution of healing first opened in the 1930s. Originally run by the religious order of Deaconess sisters, it is still referred to by many as "Deaconess." Its view of and from beautiful Forest Park lent its indelible impression and its new name.

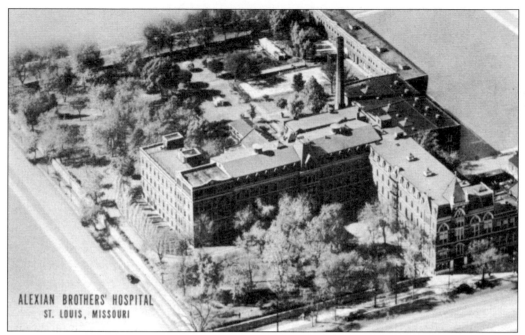

ALEXIAN BROTHERS HOSPITAL. Recently renamed St. Alexiux, this medical facility operated by the Catholic order of Alexian Brothers for over a century, is a South Broadway staple. Since its founding in 1869, it underwent expansion and reconstruction. This aerial view shows an earlier version of its complex.

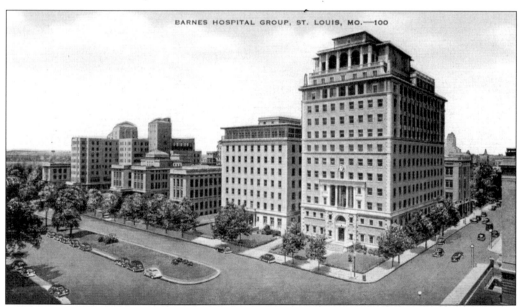

BARNES HOSPITAL PLAZA. First opening in 1914 with 26 patients, Barnes Hospital merged with Jewish Hospital in 1996, forming today's Barnes-Jewish Hospital. The result of a Washington University School of Medicine reorganization, and a bequest left by Robert A. Barnes, the giant hospital complex at its central city location now provides medical services for patients from far-reaching areas.

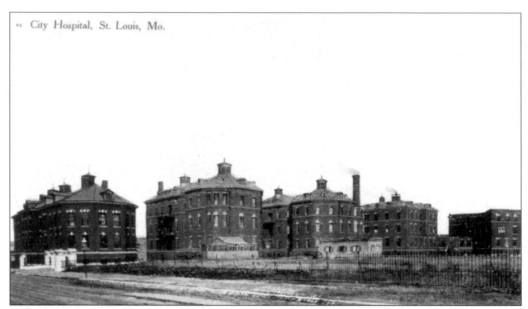

CITY HOSPITAL. This is one of the earlier versions of the City Hospital that finally closed in 1985. The first built on this site in 1846 was destroyed by fire, and the second succumbed to the devastating 1896 tornado. These buildings were part of the third reopening of 1905, but they were demolished to make room for later expansion.

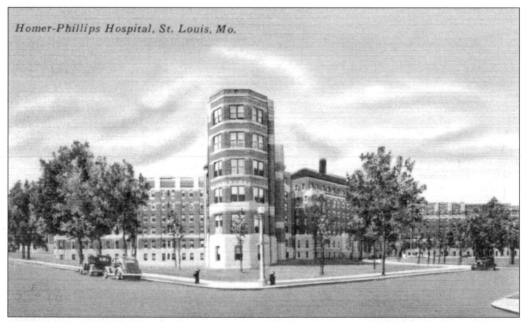

HOMER PHILLIPS HOSPITAL. Most long-time St. Louis area residents know this hospital as "Homer G," for an African American lawyer, Homer G. Phillips, who was instrumental in obtaining funding for its 1937 opening. Founded to provide medical training and care to black citizens at a time when other doors were closed to them, it served its purpose in exemplary fashion until its 1979 closing. A current renovation project is converting this valuable part of St. Louis history into residences for low and middle-income seniors.

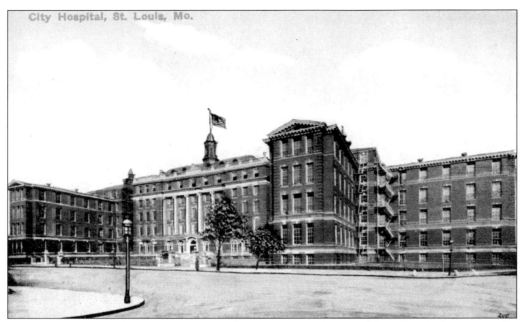

City Hospital, St. Louis, Mo.

ANOTHER VIEW OF CITY HOSPITAL. In this more recent image of City Hospital, one sees the center Administration Building (with the tall pillars). Scores of St. Louis citizens in need of treatment were carried to "City" over its 139 years of service. It remained the topic of vehement debate for years following its 1985 closing. At this writing, plans for its renovation and reuse look promising.

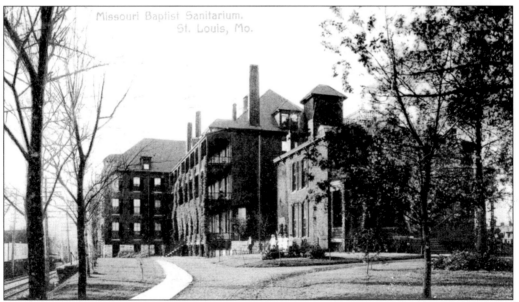

Missouri Baptist Sanitarium,
St. Louis, Mo.

MISSOURI BAPTIST SANITARIUM. This building no longer exists, but it was the first version of Missouri Baptist Hospital. Called Missouri Baptist Sanitarium when it opened at this North Taylor location in 1915, it acquired its present name in 1927. When a new building was needed, the hospital moved to its present location in the county in 1965. Now, Hopewell Baptist Church sits on these same grounds.

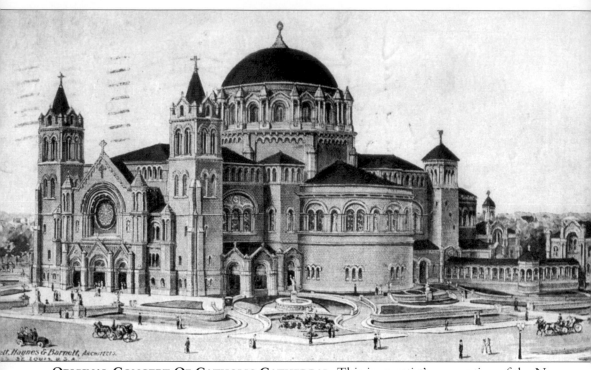

ORIGINAL CONCEPT OF CATHOLIC CATHEDRAL. This is an artist's conception of the New Cathedral (see page 59) drafted prior to its completion.

Seven
SCHOOLS

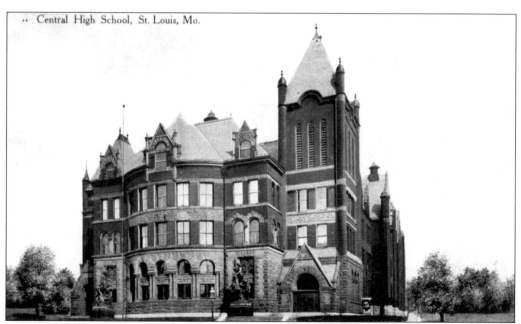

CENTRAL HIGH SCHOOL. One of the first high schools in St. Louis, this building at 1020 North Grand was destroyed in the tornado of 1927 (see page 14). The students were then transferred to Yeatman on Natural Bridge (see page 67).

TEACHERS COLLEGE. Built around 1905 by Washington University, this long stately building on Union and Enright first housed the Smith Academy and the Manual Training Academy. The St. Louis Board of Education bought it in 1917, using it for two different Bluett schools. Then, from 1948 to 1963, it was Harris Teachers College. Vacant at this writing, it was most recently Enright Middle School.

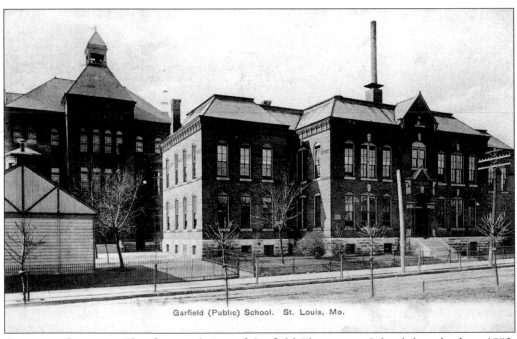

Garfield (Public) School. St. Louis, Mo.

GARFIELD SCHOOL. This first rendering of Garfield Elementary School dates back to 1882. The newer building at the same property on Wyoming replaced this structure in the 1930s.

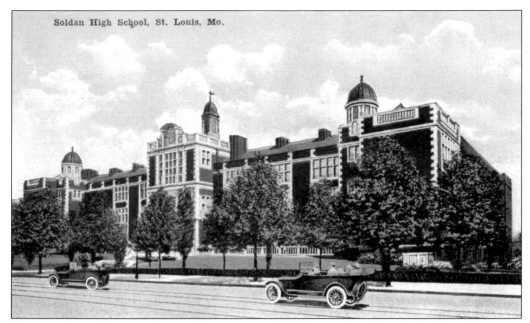

SOLDAN HIGH SCHOOL. Among the many wonderful examples of the city's rich architecture, this still-operating house of learning is one of the best preserved. First opened in 1909, Soldan's list of graduates contains a number of widely known celebrities. In 1993 it became Soldan International Studies High, a magnet school.

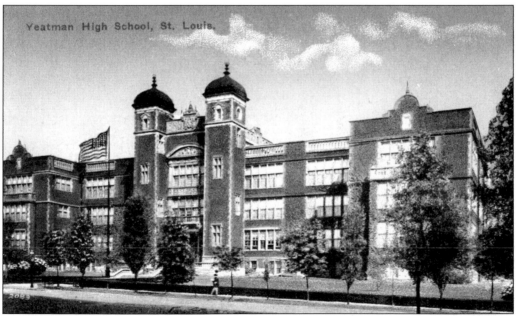

YEATMAN HIGH SCHOOL. Undergoing two name changes over time, Yeatman High at Natural Bridge and Garrison took on students from the old Central High (see page 65) when a tornado destroyed that school. In time, Yeatman came to be called Central. Now, it is Central Visual and Performing Arts High School.

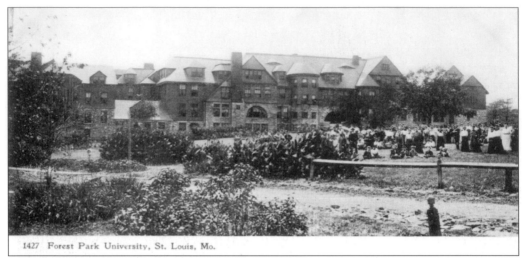

FOREST PARK UNIVERSITY. Founded and operated by Anna Sneed Cairns, a leader in the Women's Suffrage movement, this all-girls' school was near the site of the modern day Forest Park Community College. On Oakland just east of Hampton, it lasted from 1891 until sometime in the mid-1920s.

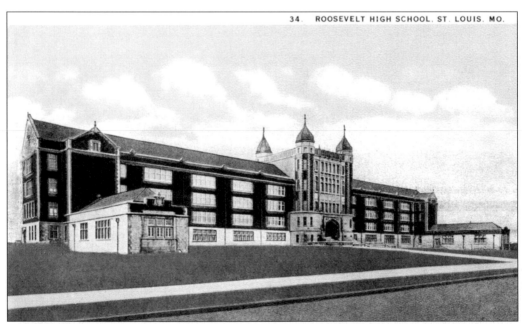

ROOSEVELT HIGH SCHOOL. Named for the 26th United States President Theodore Roosevelt, this high school opened in 1925. It has continuously served the south side ever since. A typical St. Louis conversation opener, "What high school did you go to?" will often get the answer, "I'm a Rough Rider."

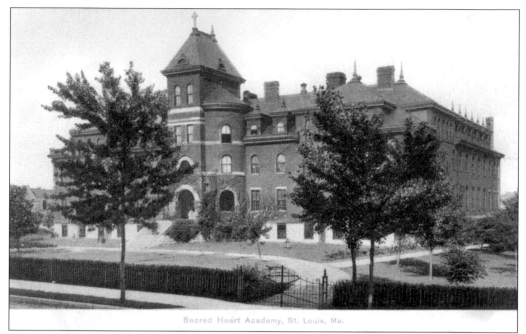

Sacred Heart Academy, St. Louis, Mo.

SACRED HEART ACADEMY. Sacred Heart Academy on Broadway was torn down in 1893, and transferred to this then-new building. Is was often called the "city house," to differentiate it from the Sacred Heart Academy in Florissant. The city house also housed a boys' school, Barat Hall, until its 1968 closing. Then, this building was razed to make room for the West End Terrace Apartments. A large pedestal that once supported a statue of the Sacred Heart still stands there.

ST. JOSEPH'S ORPHANS HOME. No longer an orphanage, this building is now the Academy of Girls and Boys Town of Missouri. At Grand and Delor near St. Mary's High School on the south side, it still maintains its dignified appearance.

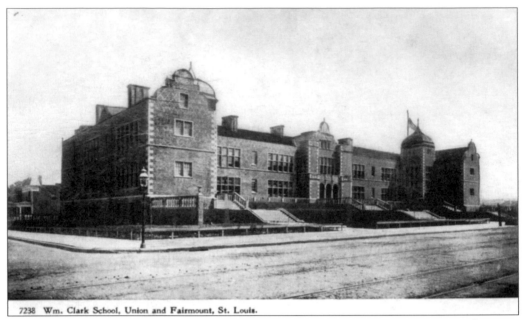

7238 Wm. Clark School, Union and Fairmount, St. Louis.

WILLIAM CLARK SCHOOL. A city elementary school, William Clark is one of Union Boulevard's well-preserved building gems (see page 15). It opened at this location in 1907 after moving from its first location on Seventh and Hickory.

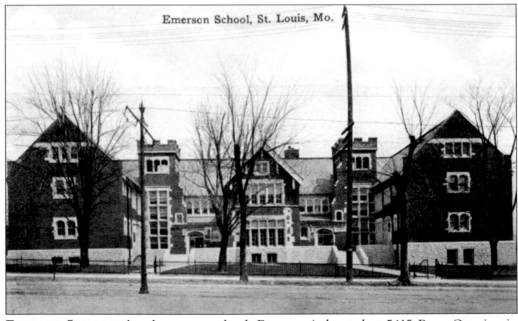

Emerson School, St. Louis, Mo.

EMERSON SCHOOL. An elementary school, Emerson is located at 5415 Page. Opening in 1902, it served the city's north side for over a hundred years.

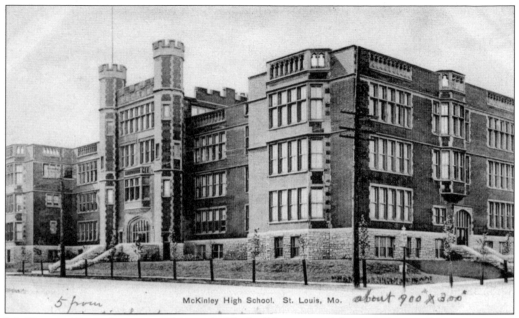

McKinley High School. St. Louis, Mo. *about 900 x 300*

MCKINLEY HIGH SCHOOL. This castle-like building named for President William McKinley, the nation's 25th, was the first public high school on the south side. Opened in 1904, it has been McKinley Classical Junior Academy for middle-school students since 1994. It holds treasured memories for countless high school graduates of yesteryear.

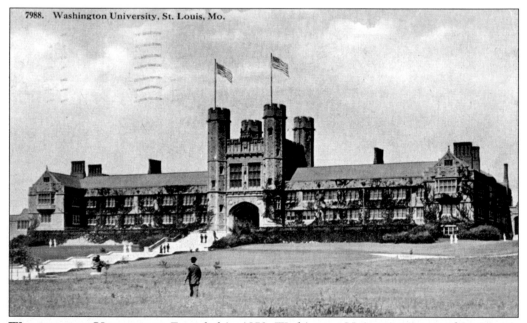

7988. Washington University, St. Louis, Mo.

WASHINGTON UNIVERSITY. Founded in 1853, Washington University is one of St. Louis's shining examples of ceaseless progress in advanced education. The building in this photo shows the beginnings of the campus that now encompasses well over two thousand acres. Its renowned school of medicine works in consort with Barnes-Jewish Hospital (see page 61).

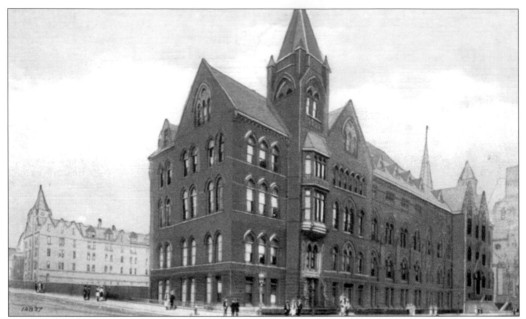

ST. LOUIS UNIVERSITY. The area of Grand Avenue and Lindell Boulevard developed around St. Louis University. Moving from its original downtown location in 1888, it then became a mainstay of the midtown area. Never changing character, this building compliments everything built since.

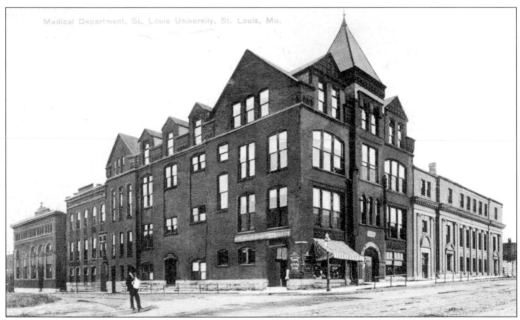

MEDICAL DEPARTMENT, ST. LOUIS UNIVERSITY. The Medical School at St. Louis University has a long and distinguished history. Since this building's erection, the school's accomplishments, along with those of the university, have exceeded anything envisioned by its builders. On Grand Avenue, not far from the building shown above, it also enhances the Grand Center plan in progress.

Eight
PARKS

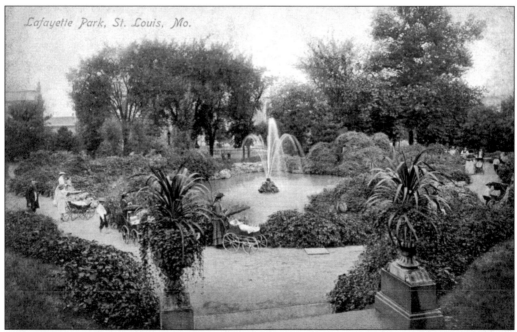

LAFAYETTE PARK. St. Louis's first public park is the center of historic Lafayette Square, known for its grand 19th century mansions. The modern game of baseball was first introduced here in the 1850s. Much later, the area later fell victim to urban decay. But, the neighborhood made a dramatic recovery when modern visionaries restored much of its original splendor. Now the Perfectos, a local Vintage Baseball team, honor the park's history by using grounds within view of this fountain for their home games.

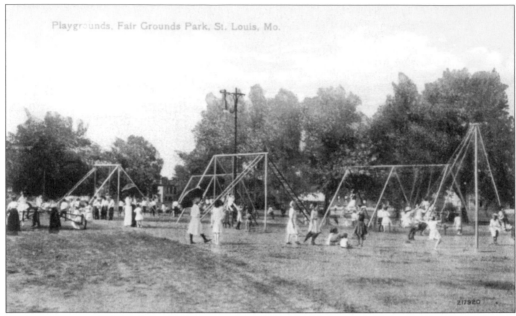

Playgrounds, Fair Grounds Park, St. Louis, Mo.

PLAYGROUND AT FAIRGROUNDS PARK. Before the Civil War, this north side park was used for an annual trade fair, a major event then. Later it had a zoo and then a swimming pool. A castle-like building that housed a bear pit is still there. Neighborhood residents continue to enjoy this public green, perhaps as much as the children in this photo. Across the street, on Vandeventer, the Cardinals once played baseball at Robison Field, where Beaumont High School stands today.

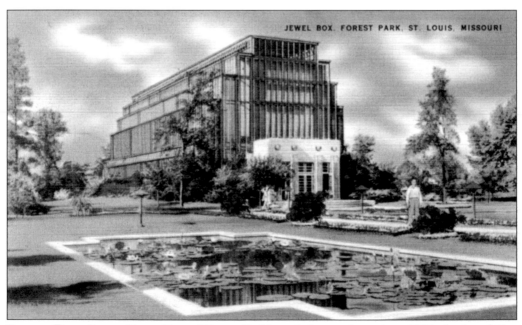

JEWEL BOX, FOREST PARK, ST. LOUIS, MISSOURI

FOREST PARK JEWEL BOX. One of Forest Park's varied attractions since 1936, the Jewel Box is the city's preeminent floral conservatory. The impressive glass and steel enclosure is as striking as the delicate plants it contains.

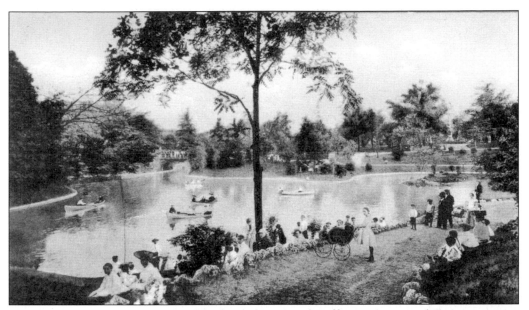

BENTON PARK. As with much of the land along South Jefferson Avenue, this site was once a cemetery. By 1865, it was converted to a city park, later named for famed Missouri Senator Thomas Hart Benton, whose statue can be seen in nearby Lafayette Park. Benton Park is still a charming pastoral place.

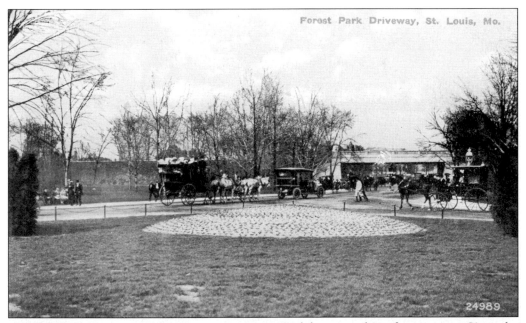

FOREST PARK DRIVEWAY. Spacious green Forest Park has something for everyone. Since the streetcar lines (now defunct) first carried visitors there in 1885, it has been a favorite place for leisure and cultural activities. This early photo does not begin to reveal the expansive acres that make up this public city grounds.

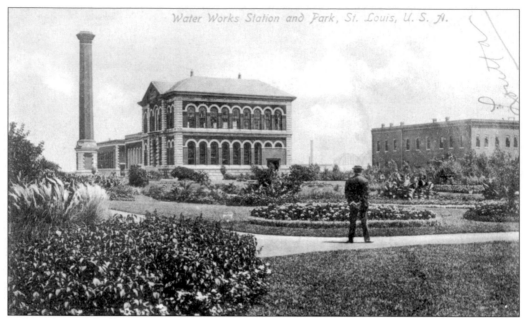

Water Works Station and Park, St. Louis, U. S. A.

WATER WORKS STATION AND PARK. Enclosed by Chain of Rocks Park and the Mississippi River, this city water works plant began operation in 1894. In sight of historic Chain of Rocks Bridge (see page 32), it can easily be viewed from winding Riverview Drive. The plant supplied crystal clear water at the time of the 1904 World's Fair. It continues to satisfy that purpose a century later.

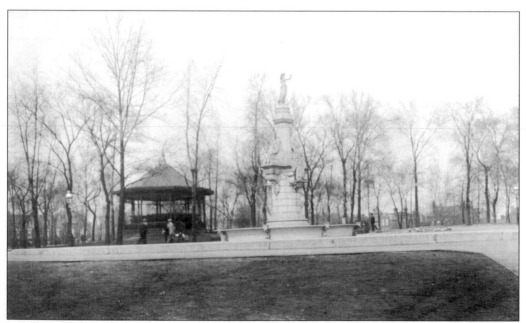

HYDE PARK. On grounds purchased from the estate of the city's first American-born physician, Dr. Bernard G. Farrar, Hyde Park has been in use since the mid-nineteenth century. Enclosed by the north side neighborhood (see page 34) that adopted its name, it is within several blocks of the McKinley Bridge.

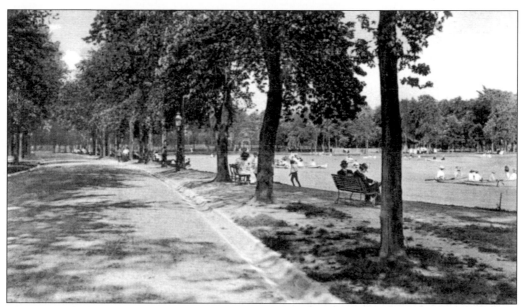

O'FALLON PARK. Since 1876, this large city park seen sprawling along West Florissant Avenue has always been a refuge from hectic city life. Today, nature lovers can be seen picnicking beneath its tall shade trees.

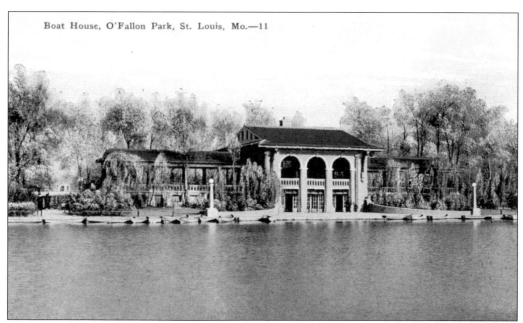

Boat House, O'Fallon Park, St. Louis, Mo.—11

BOAT HOUSE AT O'FALLON PARK. This early enchanting scene with O'Fallon Park's lake captures a dreamy mood. It demonstrates St. Louis's love affair with waterways and parks.

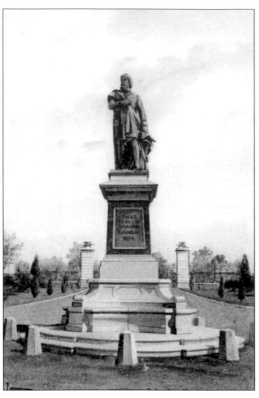

COLUMBUS MONUMENT AT TOWER GROVE PARK. Centered just beyond the elegant gateway entrance, this likeness of Christopher Columbus still greets Tower Grove Park visitors today. The 276 acres donated by Henry Shaw (see page 81) in 1868 make up this serene and beautiful park.

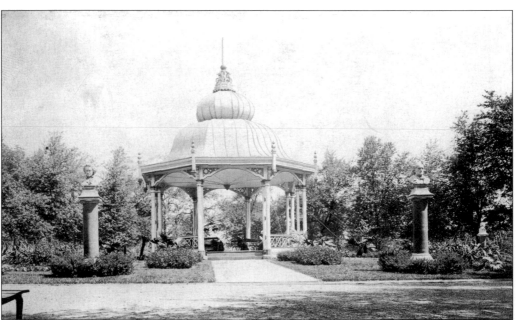

TOWER GROVE PARK PAGODA. Scenes like this in Tower Grove explain the park's status as a National Historic Landmark. This pagoda, guarded by the two music composer busts, looks the same today as it does in this vintage photo. Adding to the cultural air, summer evening band concerts still entertain music lovers.

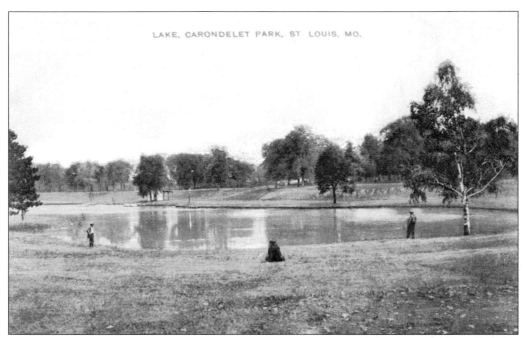

LAKE, CARONDELET PARK, ST. LOUIS, MO.

CARONDELET PARK LAKE. Lakes in this park were developed by enlarging a series of sinkholes. Located in what was the original village of Carondelet, founded in 1767, the park was established in 1876, six years after Carondelet annexed to St. Louis.

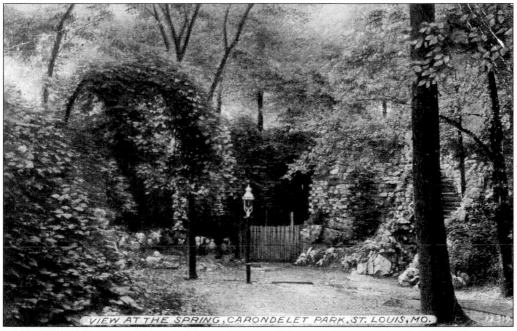

VIEW AT THE SPRING, CARONDELET PARK, ST. LOUIS, MO.

VIEW AT SPRING, CARONDELET PARK. This restful view of Carondelet Park is indicative of the natural beauty seen in this very large city park. Nearby, some of the oldest, and still maintained, buildings in St. Louis lie in the historic Carondelet neighborhood.

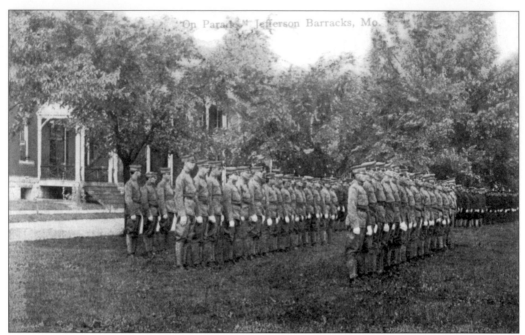

SOLDIERS IN FORMATION AT JEFFERSON BARRACKS. Established in 1826, Jefferson Barracks was situated on land purchased from the Village of Carondelet for a $5 gold piece. By the 1840s, it was the largest military post in the country. Now it is Jefferson Barracks County Park.

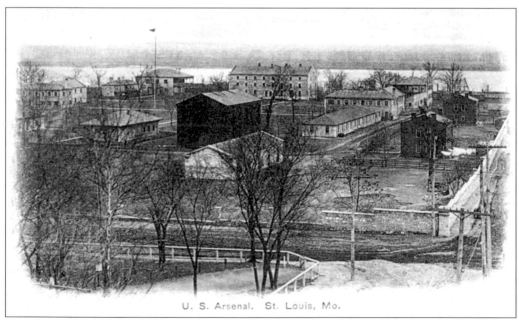

U. S. Arsenal. St. Louis, Mo.

U.S. ARSENAL. At the foot of Arsenal Street by the Mississippi River, this area once occupied by a U. S. Arsenal is still government property. The Army Corps of Engineers' sign there reads "St. Louis District Service Base—Established 1882." Stone walls still surround the large U.S. Mapping Agency to the rear.

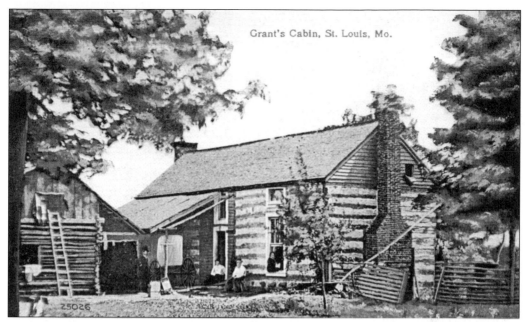

Grant's Cabin, St. Louis, Mo.

GRANT'S CABIN. Ulysses S. Grant built this log cabin he called "Hardscrabble" on his farm years before he became the nation's 18th president. It can be seen near the Busch estate on Gravois Road.

HENRY SHAW'S MAUSOLEUM. This mausoleum is located within the Missouri Botanical Garden. Also known as Shaw's Garden, the botanical gardens opened in 1859 on Henry Shaw's country estate. In addition to his residence and burial site, greenhouses and lush gardens continue to attract the multitudes.

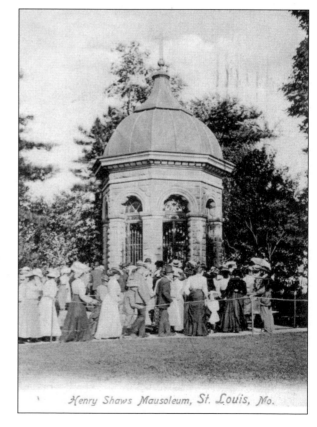

Henry Shaws Mausoleum, St. Louis, Mo.

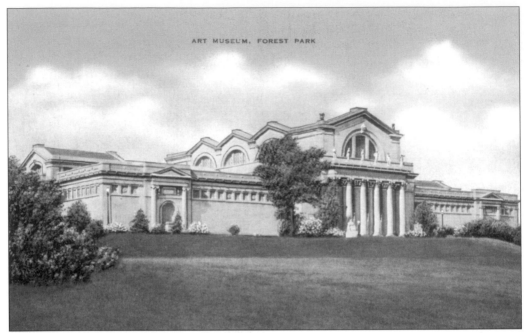

ART MUSEUM, FOREST PARK

ART MUSEUM AT FOREST PARK. This building now called the St. Louis Art Museum is the one remaining Forest Park building constructed for the 1904 Fair. Situated behind Festival Hall (see pages 100 and 101) on Art Hill, it was originally the fair's Palace of Fine Arts (see page 105).

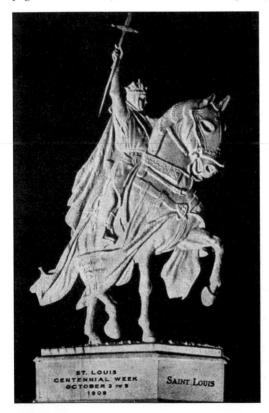

STATUE OF ST. LOUIS 1909. This postcard featuring the long-time symbol of St. Louis called "Apotheosis of St. Louis," superimposes an announcement of the city's Centennial Week, October 3–9, 1909.

STATUE OF ST. LOUIS. This photo of the statue described on page 82, displays the larger than life bronze casting as it still appears today. Erected in 1906, it is a much-enlarged version of the one displayed at the 1904 World's Fair.

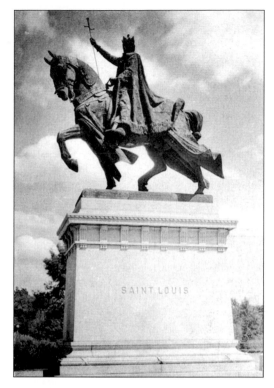

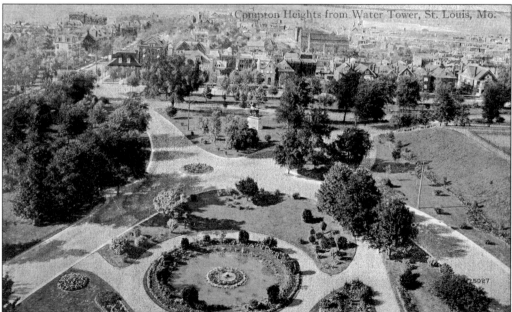

VIEW FROM THE COMPTON HEIGHTS WATER TOWER. From the vantage point of the Compton Heights Water Tower (see page 35), one could view this park area and the homes lining Compton Hill Drive. Years after this picture was taken, Highway 44 cut into a good portion of the land seen to the left. But many of the remaining Compton Hill homes seen here are still intact.

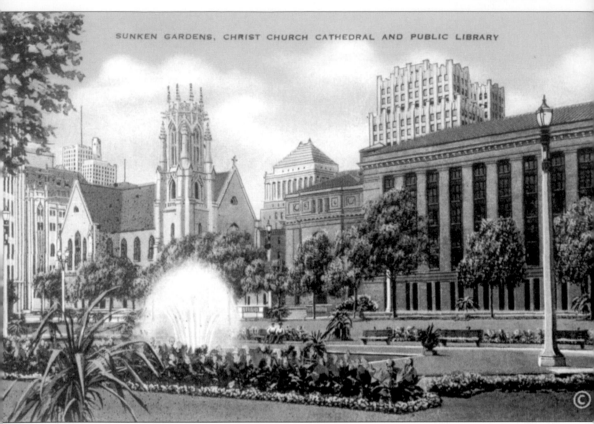

SUNKEN GARDENS. Enriching the downtown landscape for many years, everything shown here, including the Sunken Gardens, still exists. Highlighted are Christ Church Cathedral and the rear of the Central Public Library. The 1920s-built Missouri Pacific Building can be viewed behind the library on the far right.

Nine
Baseball and Other Attractions

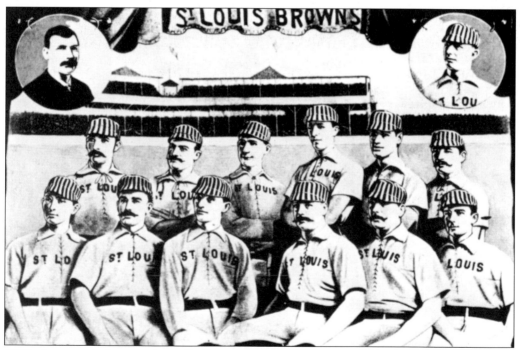

1880s American Association St. Louis Brown Stockings. This champion major league baseball team played at old Sportsman's Park at Grand and Dodier (see page 86) in the 1880s. Its colorful owner Chris Von der Ahe (left) and team captain Charles Comisky (right) are circled at the top of this card. Comisky later gained fame as owner of the Chicago White Sox.

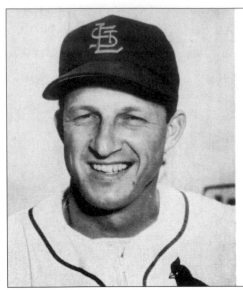

Dear Friend:
We're happy to have so many good fans supporting us. All the Cardinal players are grateful for it.
Sincerely,

STAN MUSIAL GREETING. This postcard greeting from "Stan the Man" shows the slugger during his stellar career as a St. Louis Cardinal (1941–1963). A popular St. Louis figure even now, his towering statue outside Busch Stadium downtown displays his unorthodox batting stance.

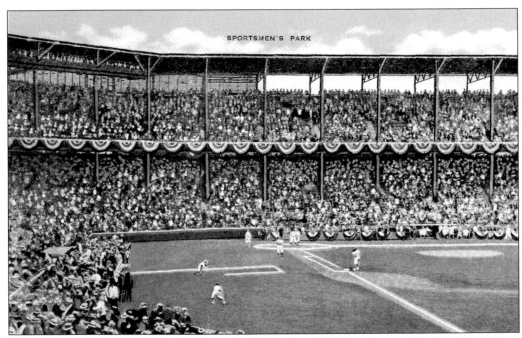

EARLY IMAGE OF SPORTSMAN'S PARK. This rendering of old Sportsman's Park on Grand and Dodier portrays it as it appeared in the late 19th and early 20th centuries. Historians date the first baseball diamond on these grounds to 1866.

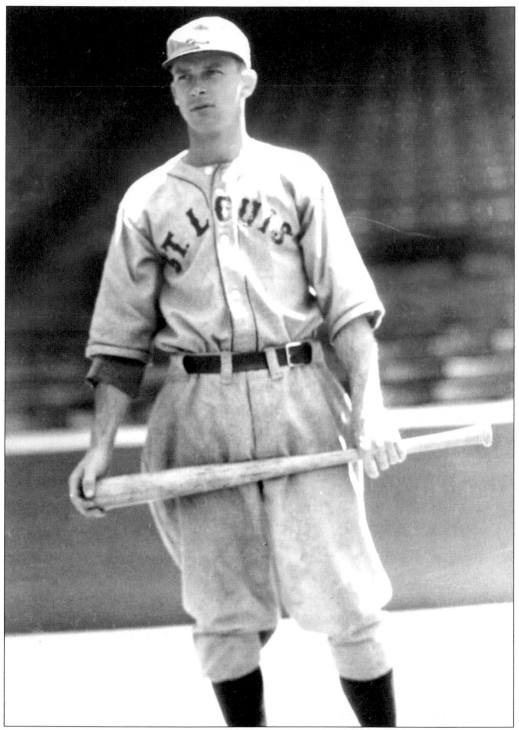

1930s AMERICAN LEAGUE ST. LOUIS BROWNS PLAYER. This postcard photo of Art Scharien, who played for the American League Browns in the 1930s, clearly shows the loose-fitting wool uniforms of the times.

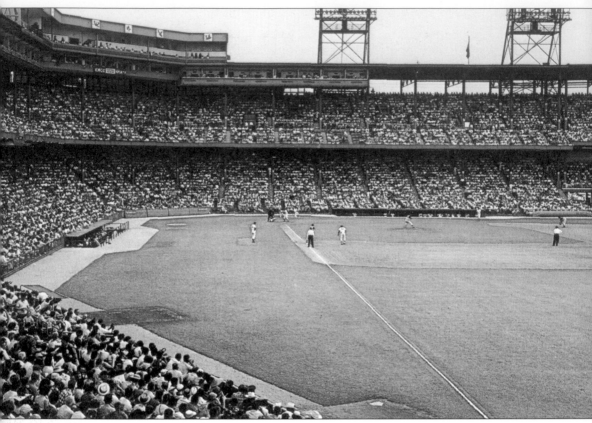

SPORTSMAN'S PARK WITH LIGHT STANDARDS. Sportsman's Park finally got lights in 1940. The Browns and the Cardinals shared this park until the Browns moved to Baltimore to become the Orioles in 1954. The stadium is long gone, but kids from the Herbert Hoover Boys and Girls Club, now at the site, play baseball on the diamond there.

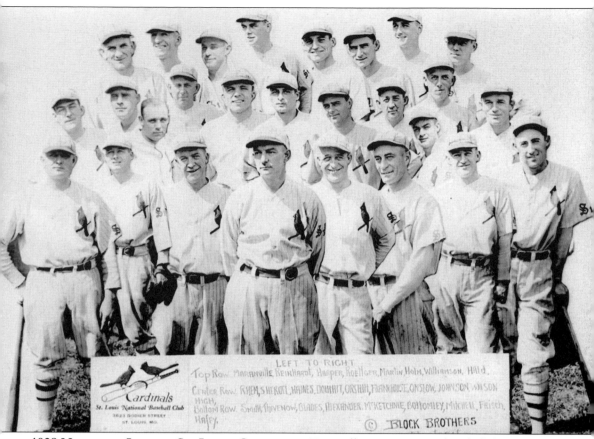

LEFT TO RIGHT
Top Row: Maranville, Reinhardt, Harper, Roettger, Martin, Holm, Williamson, Hild.

Center Row: Rhem, Sherdel, Haines, Douthit, Orsatti, Frankhouse, Onslow, Johnson, Wilson.

High.

Bottom Row: Smith, Thevenow, Blades, Alexander, McKechnie, Bottomley, Mitchell, Frisch, Hafey.

Cardinals
St. Louis National Baseball Club
3623 DODIER STREET
ST. LOUIS, MO.

© BLOCK BROTHERS

1928 NATIONAL LEAGUE ST. LOUIS CARDINALS. For well over a century, baseball fans have supported the St. Louis Cardinals. This 1928 team photo shows just a few of the many players to don the club uniform over that time. The uniforms change somewhat, but the game itself is basically the same.

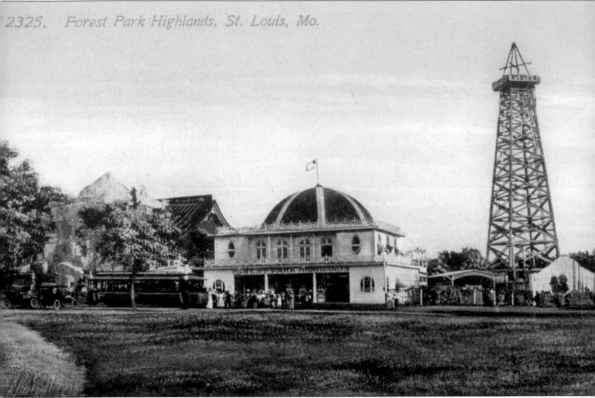

FOREST PARK HIGHLANDS. An amusement park dating back to 1896 entertained St. Louis area residents for over sixty years. Memories of its popular thrill rides continue to delight those old enough to remember. Now the site of St. Louis Community College, the Forest Park Highlands burned in 1963.

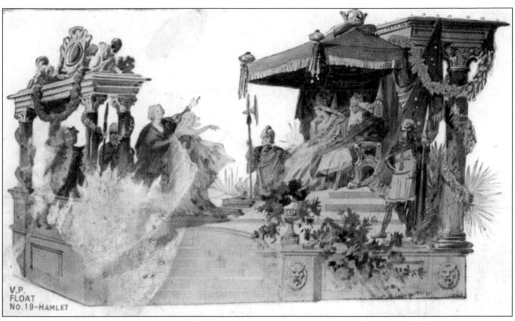

V.P
FLOAT
No.19-HAMLET

VEILED PROPHET PARADE FLOAT 1916. Starting in the 1870s, the annual visit of the Veiled Prophet ushered in a ball and a parade with floats such as this. Now, the city's Independence Day celebration at the riverfront is called the VP Fair.

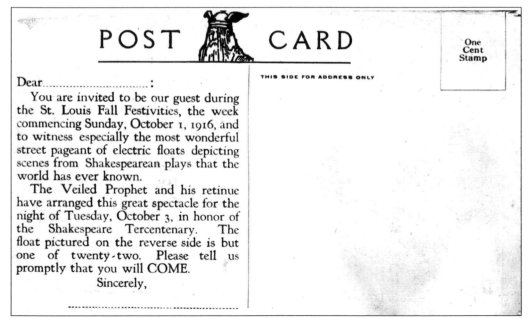

POST CARD

One
Cent
Stamp

Dear.........................:

THIS SIDE FOR ADDRESS ONLY

You are invited to be our guest during the St. Louis Fall Festivities, the week commencing Sunday, October 1, 1916, and to witness especially the most wonderful street pageant of electric floats depicting scenes from Shakespearean plays that the world has ever known.

The Veiled Prophet and his retinue have arranged this great spectacle for the night of Tuesday, October 3, in honor of the Shakespeare Tercentenary. The float pictured on the reverse side is but one of twenty-two. Please tell us promptly that you will COME.

Sincerely,

...

REVERSE SIDE OF FLOAT POSTCARD. The reverse side of the card shown above is an invitation to a pageant of 22 floats to begin on October 1, 1916.

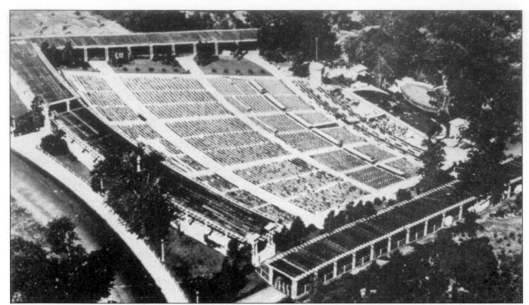

AERIAL VIEW OF MUNICIPAL OPERA. At first called the Municipal Open Air Theatre, the amphitheater soon gained the name "Muni," and became a permanent Forest Park attraction in 1917. This picture allows a view of all the seating, including the popular free seats in back.

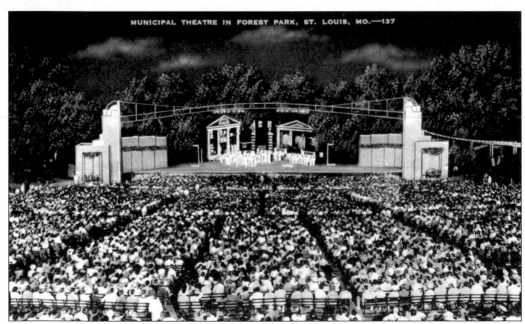

MUNICIPAL OPERA AT NIGHT. In this scene showing a production in progress, one gets a feel for what it's like to see theatre under the stars. To this day locals and out-of-town visitors relish the Muni experience.

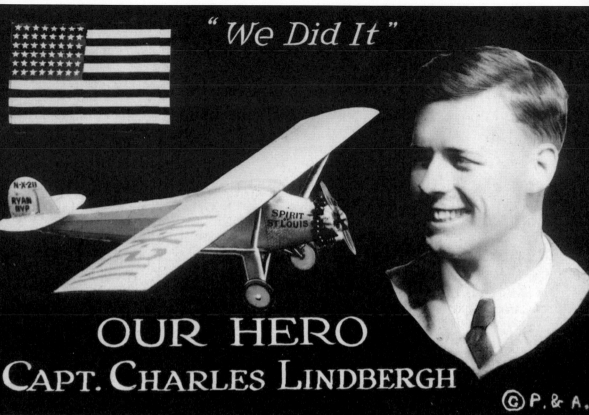

CHARLES LINDBERGH CELEBRATION. After aviator Charles Lindbergh made the first nonstop flight across the Atlantic in 1927, he received postcards of congratulations from all reaches of the earth. This card displays the plane he designed himself and built with St. Louis-acquired funding, which accounts for its name, *Spirit of St. Louis*. Notice that the American flag had only 48 stars then.

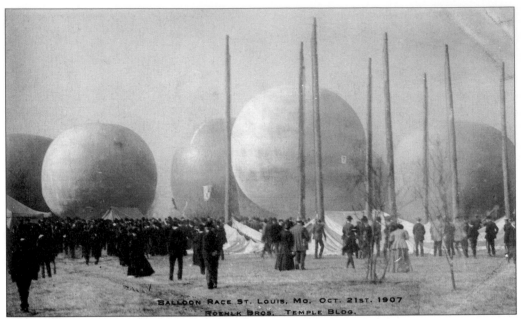

1907 BALLOON RACE. To this day a favorite St. Louis activity, balloon racing entices spectators and participants alike. The local newspaper reported that this race on October 21, 1907 began from Forest Park at 4 p.m.

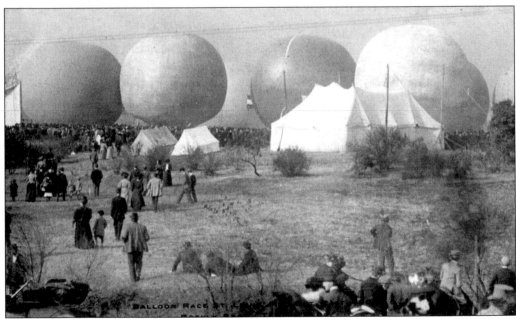

ANOTHER VIEW OF 1907 BALLOON RACE. Another, more distant view of the balloon race described above shows men, women, and children alike observing the action. The media called the balloonists aeronauts.

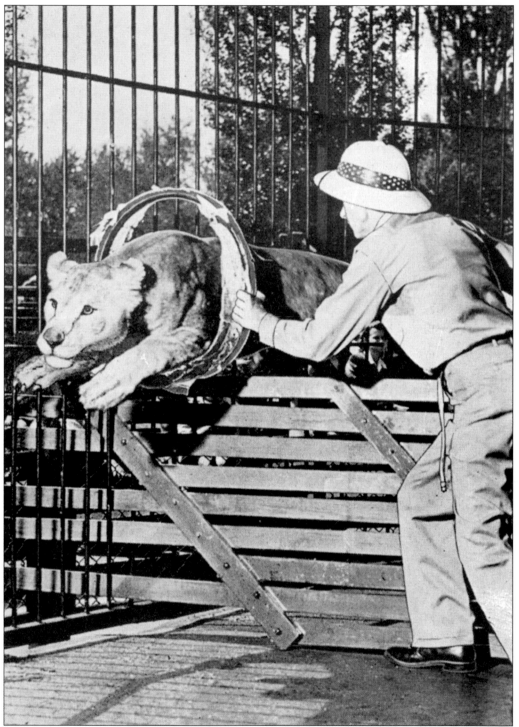

ANIMAL TRAINING AT ST. LOUIS ZOO. A major Forest Park attraction, free to the public since it opened in the 1890s, the St. Louis Zoo is among the best in the country. This is one of a series of photo postcards produced in the 1940s.

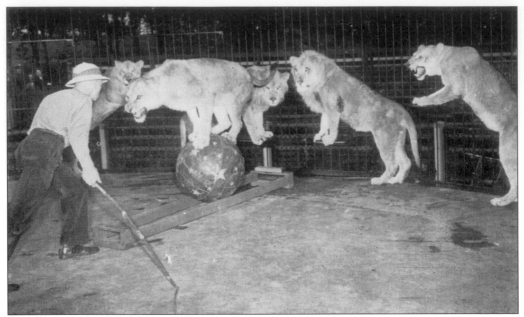

LION TAMER AT ST. LOUIS ZOO. For years, the lion show amazed and thrilled audiences at the St. Louis Zoo. Now visitors can appreciate large felines like this in a more realistic setting, Big Cat Country.

CHIMP ARENA. Dedicated in 1942, this amphitheater held hoards of zoo-goers, fascinated by the performing chimpanzees, for years. By 2003, the natural behaviors of the chimps, as well as gorillas and orangutans, could be observed in a simulated native surrounding, Jungle of the Apes.

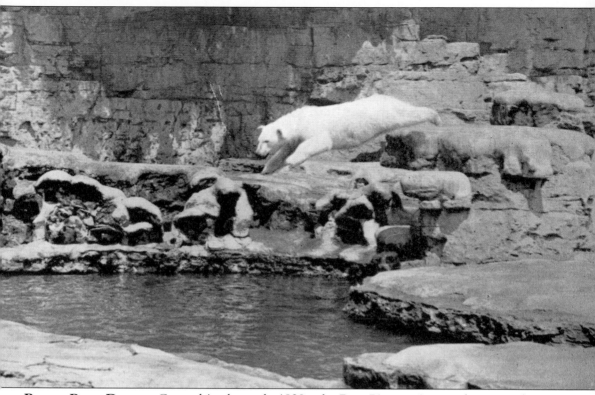

POLAR BEAR DIVING. Created in the early 1920s, the Bear Pits continue to be a popular zoo attraction. The St. Louis Zoo was one of the first in the world to replace barred cages with open, moated enclosures.

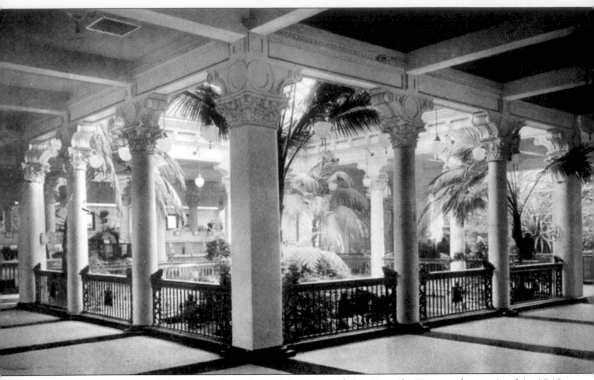

REPTILE HOUSE. The Spanish-style architecture of the Reptile House shown in this 1940s photo delights reptile aficionados even today. Now called the Charles H. Hoessle Herpitarium, it is home to reptiles and amphibians.

Ten
1904 WORLD'S FAIR

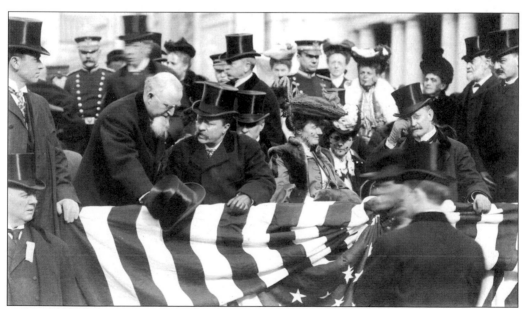

OPENING CEREMONY. In 1904, nearly 200,000 people came to Forest Park to witness the opening of the Louisiana Purchase Exposition. Seen in this photo are then U.S. Secretary of War, later 27th President William Howard Taft, and former St. Louis Mayor and then Missouri Governor David Rowland Francis. Taft is seated on the left conferring with the standing man leaning toward him. Francis is seated on the right, adjusting his spectacles.

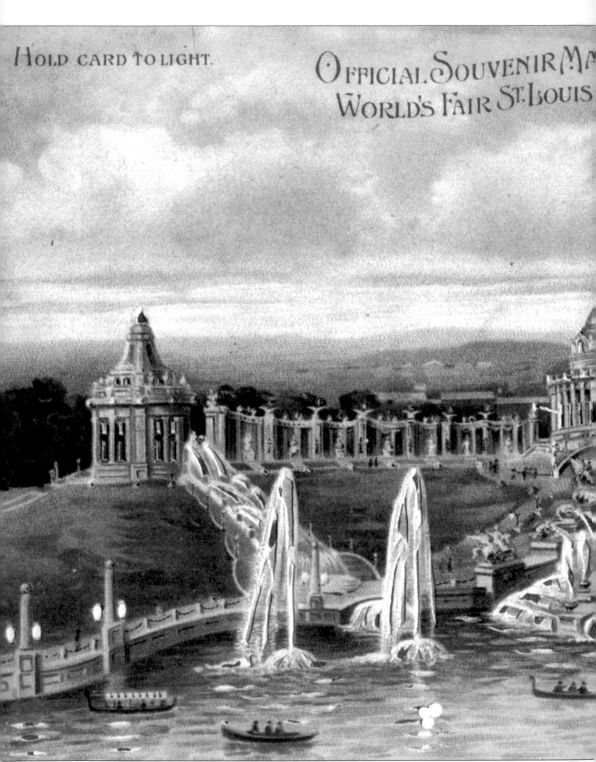

CASCADE GARDENS AND GRAND BASIN. One of a great many "Hold Card to Light" postcards picturing the 1904 Fair, this oversized postcard view is what was called the "Main

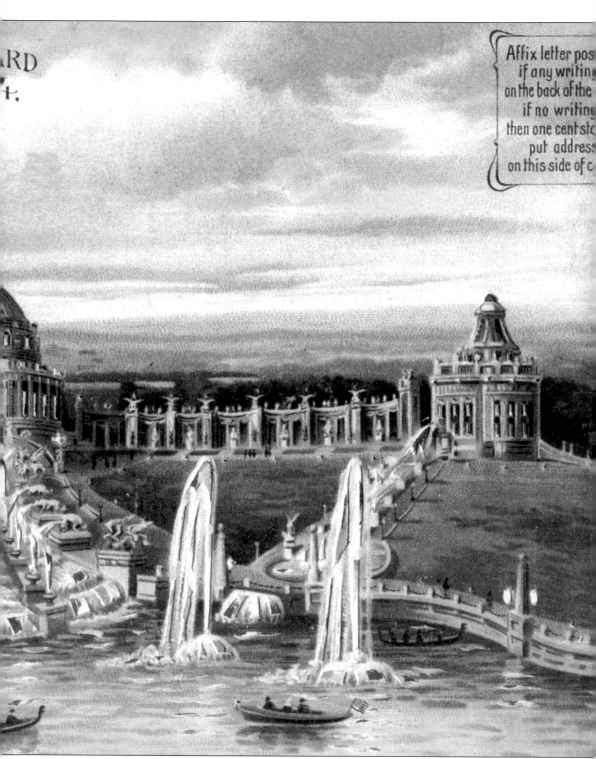

Picture." The Festival Hall in the center was at the top of Art Hill. It contained what was described as the world's biggest organ.

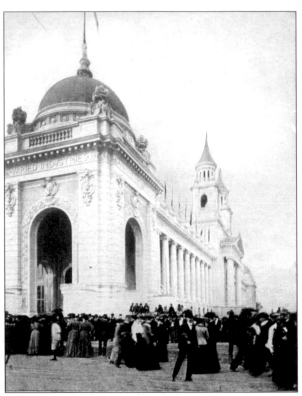

VIEW OF DEDICATION DAY. Fair patrons crowd around the Palace of Varied Industries on Dedication Day.

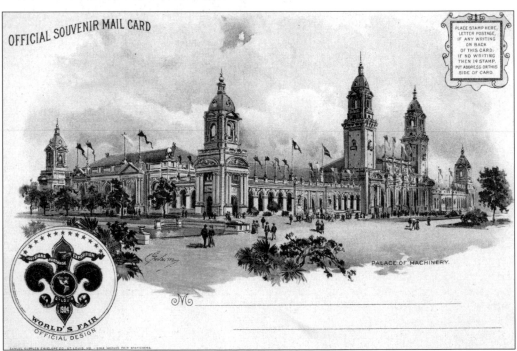

OFFICIAL SEAL. This image of the immense Palace of Machinery displays the official World's Fair seal.

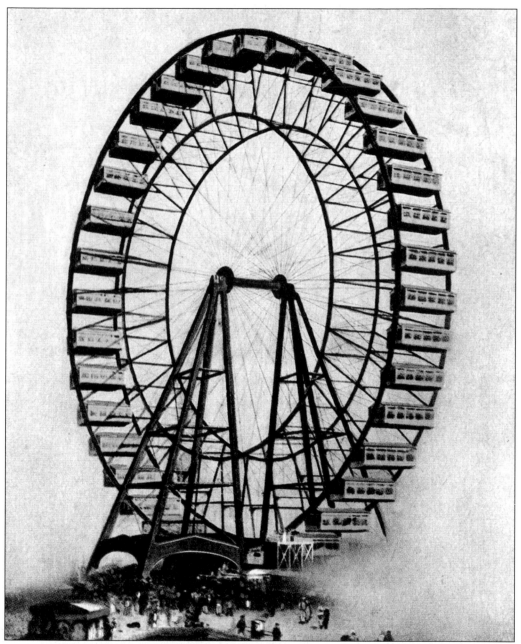

OBSERVATION WHEEL. Technically, this "Ferris Wheel" was the Observation Wheel. Its 36 cars, each able to carry 60 passengers, carried riders 264 feet above the Fair, allowing them a panoramic view. And for only 50¢! It is said that part of this attraction is buried somewhere in Forest Park.

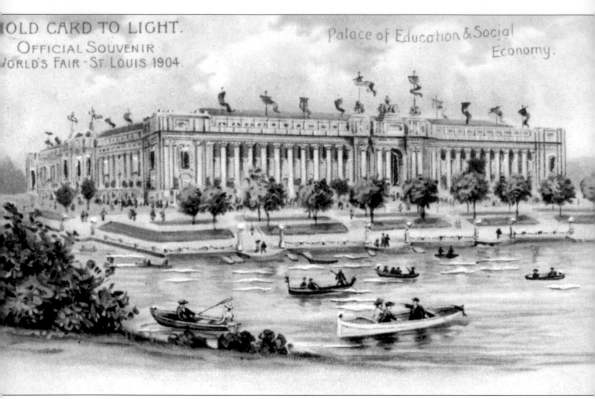

PALACE OF EDUCATION. The Fair's Palace of Education featured wax figures from a German medical school, each showing a different kind of disease. Inside, visitors could also witness children learning reading, writing, and arithmetic by the most up-to-date methods.

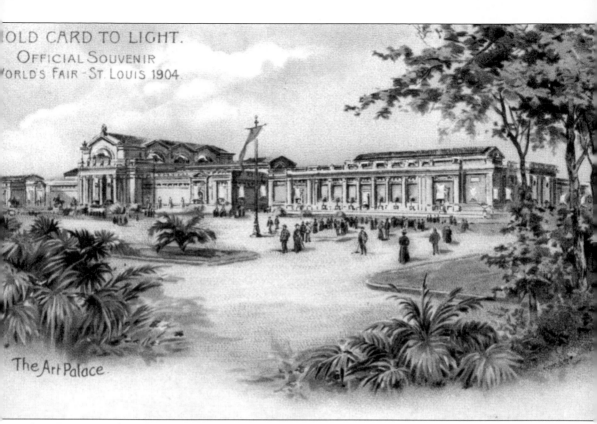

The Art Palace.

ART PALACE. The taller, pillared structure in this picture, built as the Art Palace for the fair, is now the central part of the St. Louis Art Museum (see page 82). It was built of more durable materials than the other Fair buildings, and is the only one remaining. Still free to the public, it now provides cultural enrichment to all as it did then.

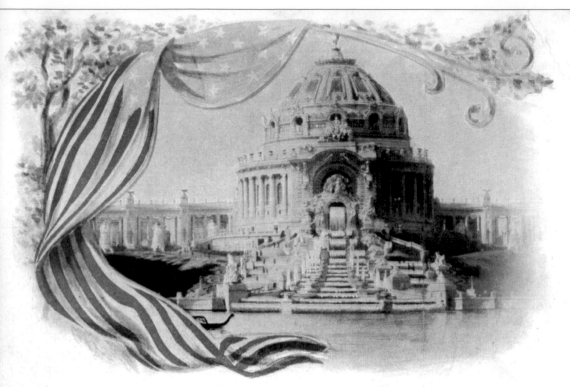

FESTIVAL HALL AND CENTRAL CASCADES
Louisiana Purchase Exposition, St. Louis, 1904
200 feet in diameter. Seats 3500 people. Cost about $1,000,000.00

FESTIVAL HALL AND CENTRAL CASCADES. This artfully framed rendition of the Festival Hall made a great souvenir for collectors in 1904, as it still does today.

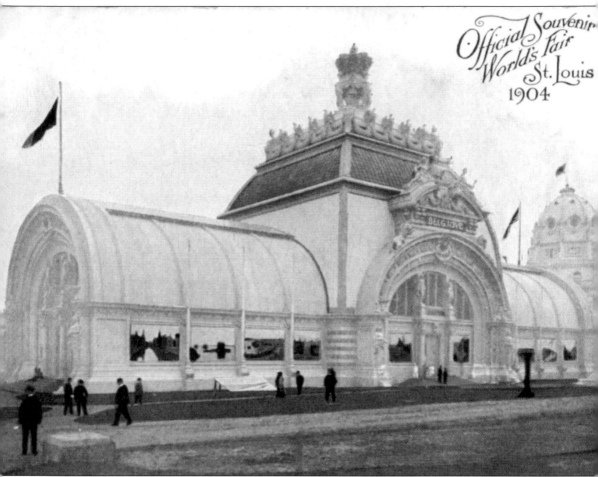

BELGIUM BUILDING. This is one of the structures that represented foreign countries at the Fair. It contained an old 16th century Flemish dining room. Later, this Belgium Building was purchased and moved to Dorcas Street near the Mississippi River, and used as the main building for the Adolphus Busch Glass Manufacturing Company (no longer in existence).

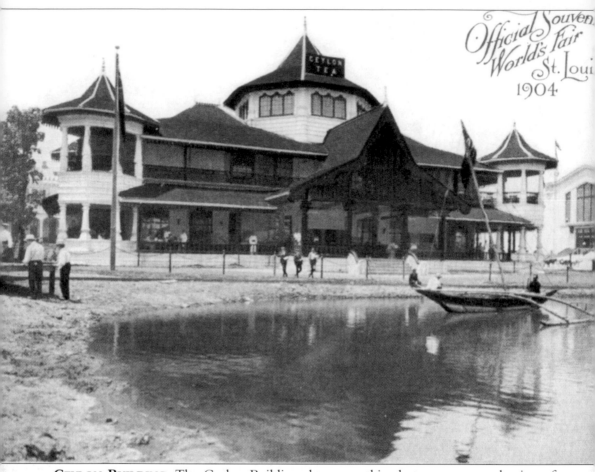

CEYLON BUILDING. The Ceylon Building shown on this photo was a reproduction of a Kandian Temple. The Fair offered a tour of the world without leaving the St. Louis city limits.

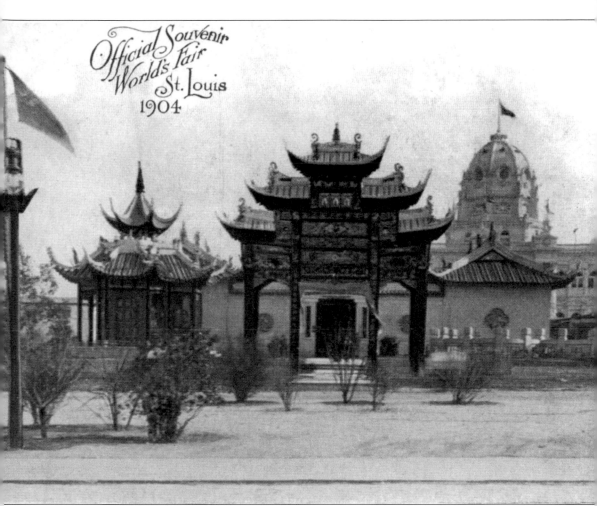

CHINA BUILDING. China's entry was a reproduction of the summer home of the Manchu Prince Pulun, Imperial Commissioner to the World's Fair.

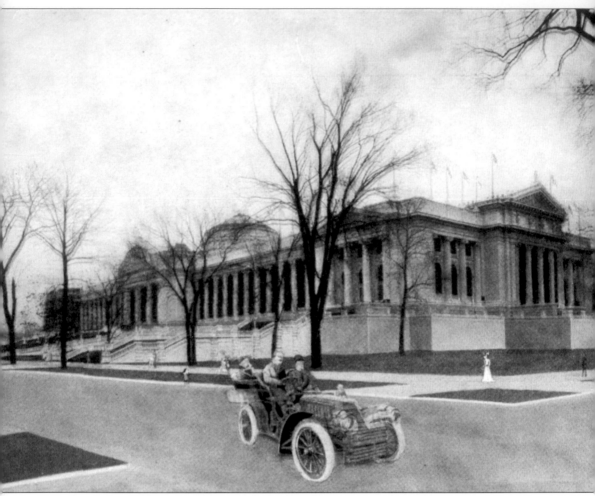

U. S. GOVERNMENT BUILDING. Announcing your tax dollars at work, this postcard displays the Fair's U.S. Government Building. Its cost of $450,000 was a considerable sum then, especially considering that it was not meant to last longer than the event for which it was built.

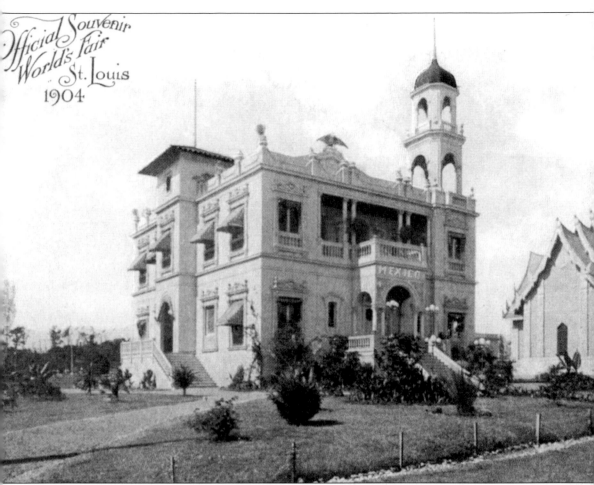

MEXICO BUILDING. The Mexico Building contained a large public reception room and a central patio. The commission's office opened from the balcony.

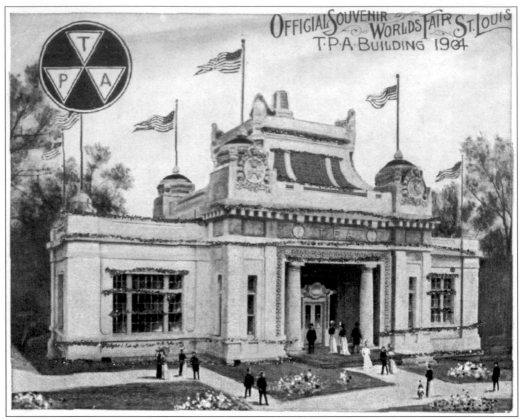

TPA Building. This Fair building proudly displaying a number of American flags is the Temple of the Travelers Protective Association.

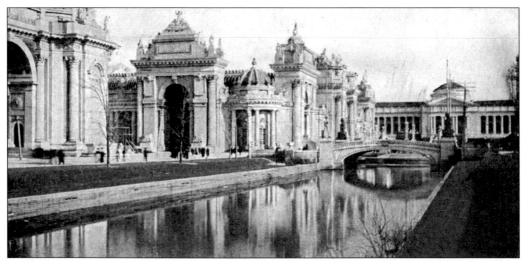

Looking East on Lagoon. One can easily appreciate the magnitude of the Fair and its buildings by the ant-like visitors in this view of a lagoon.

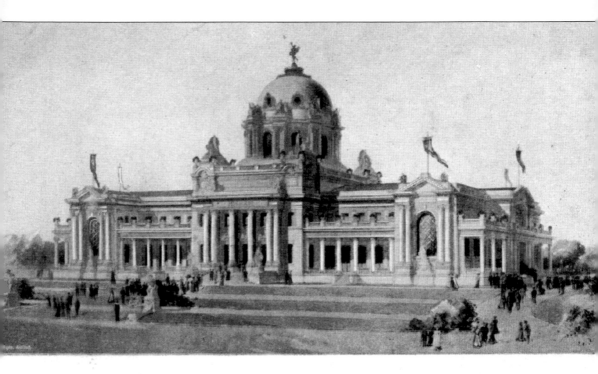

MISSOURI STATE BUILDING
Louisiana Purchase Exposition, St. Louis, 1904

MISSOURI STATE BUILDING. Missouri's was the largest and finest of the buildings representing separate states in the Union. Plus, it had the added convenience of a heating and cooling system. Consequently, it was often used for special social events.

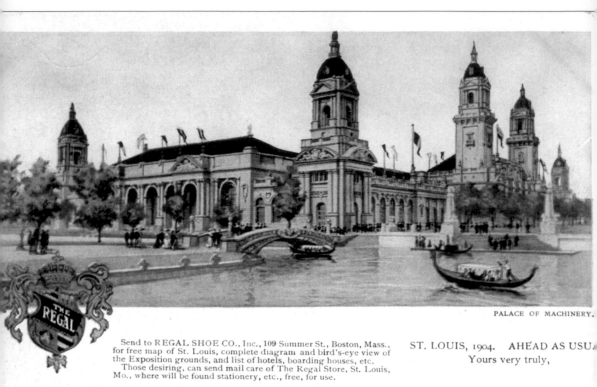

PALACE OF MACHINERY.

REGAL SHOE COMPANY AD WITH PALACE OF MACHINERY. Distributed free through the Regal Shoe Company outlet in St. Louis, this is one of six view cards produced for the Boston based company. Note the "St. Louis 1904—Ahead as usual" printing on the right.

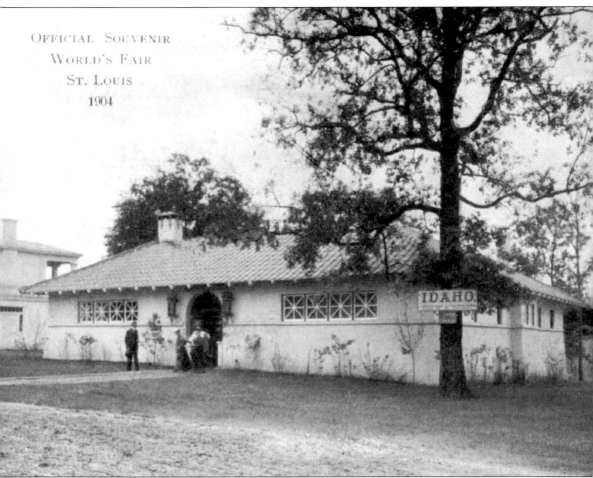

IDAHO STATE BUILDING. Each of the states in the Union represented at the Fair had its own building. People from around the world could gather an impression of this country's diversity.

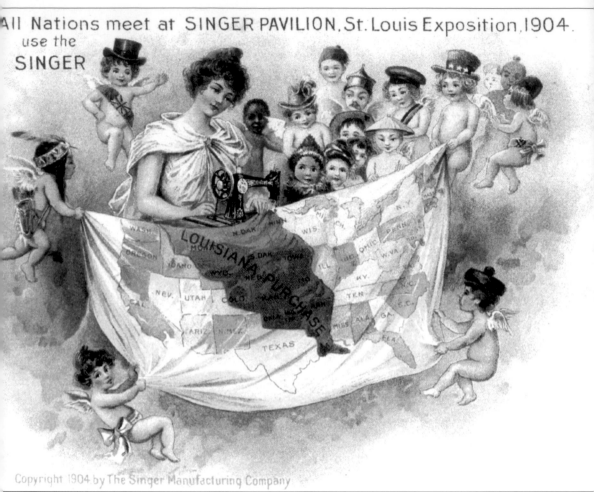

SINGER PAVILION. This is another of the numerous advertisement cards given away at the Fair. An extraordinarily attractive piece of artwork, it was printed for the Singer Manufacturing Company.

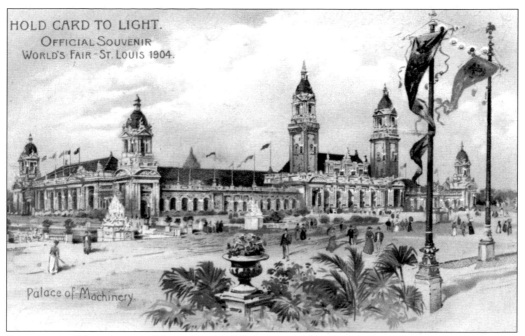

PALACE OF MACHINERY. The same building seen in the Regal Shoe Company ad on page 114, the Palace of Machinery was the subject for a number of cards.

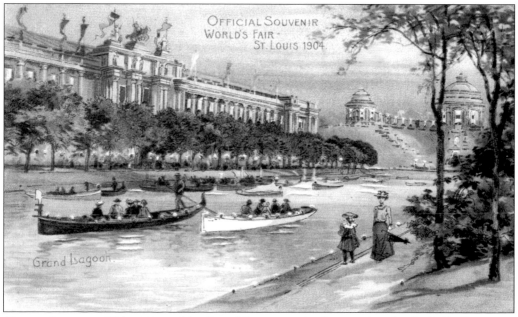

GRAND LAGOON. This vision of the Grand Lagoon emits the mood set by the Italian boatmen who serenaded passengers while guiding gondolas through the lagoons.

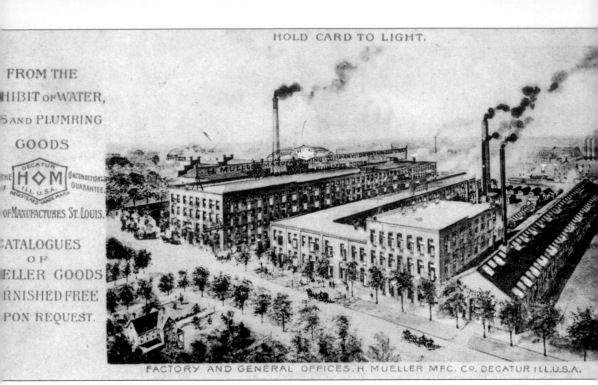

H. Mueller Manufacturing Co. A novelty for collectors and browsers alike, this advertising card pictures the H. Mueller Manufacturing Company at its Illinois location. Yet, the inscription reads "From The Exhibit of Water, Gas & Plumbing Goods."

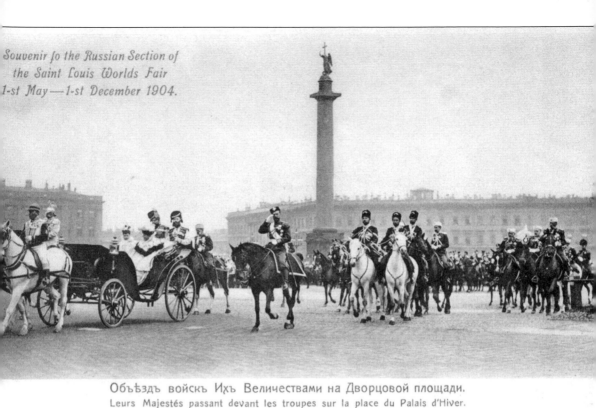

Souvenir fo the Russian Section of
the Saint Louis Worlds Fair
1-st May — 1-st December 1904.

Объѣздъ войскъ Ихъ Величествами на Дворцовой площади.
Leurs Majestés passant devant les troupes sur la place du Palais d'Hiver.

RUSSIAN SOUVENIR. Some foreign countries issued their own souvenir cards for the exposition. This Russian souvenir is one of those. An oddity, it pictures a non-exhibition subject like the ad card shown on the opposite page. This photo was obviously not taken in St. Louis, or anywhere else in North America.

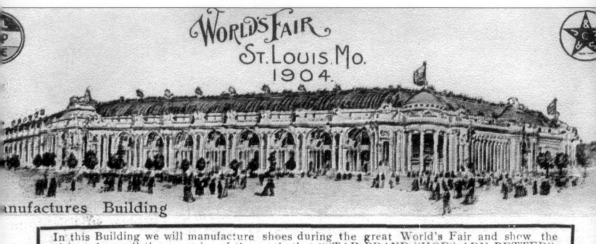

WORLD'S FAIR
ST. LOUIS. MO.
1904.

Manufactures Building

In this Building we will manufacture shoes during the great World's Fair and show the visitors from all the countries of the earth that "STAR BRAND SHOES ARE BETTER".

I will see you about ___May 10___ with th
largest line of STAR BRAND SHOES we have ever shown. We ha
another big factory which makes ten thousand pairs daily and are bett
prepared than ever to make good shoes.

Representing

ERTS, JOHNSON & RAND SHOE CO.
ST. LOUIS,

STAR BRAND SHOES AD. The saying "First in booze, first in shoes, and last in the American League" is partially explained by the many references to shoes on St. Louis picture postcards. This interesting ad is an invitation to see shoes manufactured at the Fair.

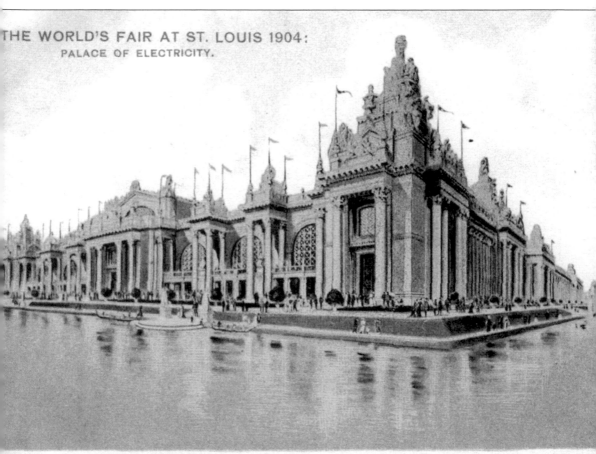

THE WORLD'S FAIR AT ST. LOUIS 1904:
PALACE OF ELECTRICITY.

Compliments of The Wm. Barr Dry Goods Co., St. Louis, Mo.
Sole Importers of The "Empress Brand Hosiery".

WM. BARR DRY GOODS SOUVENIR, PALACE OF ELECTRICITY. Hoards of spectators were awed by a demonstration of the modern wireless telegraph in the Palace of Electricity. St. Louis residents will instantly recognize the name Barr printed at the bottom of this complimentary card.

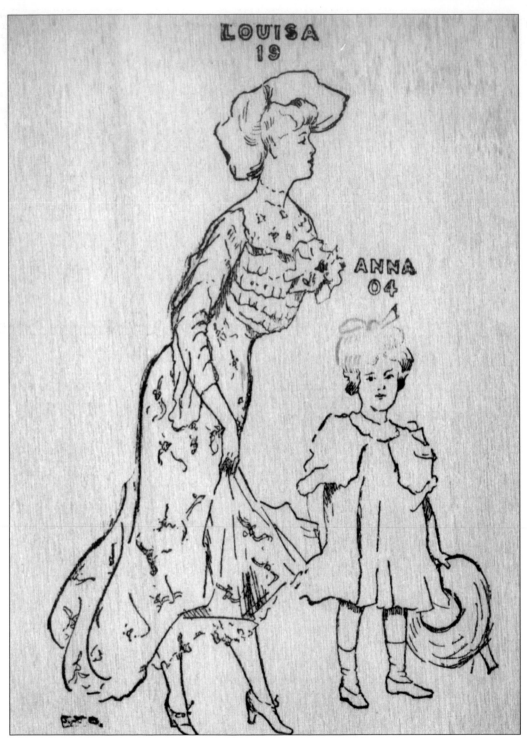

WOODEN SOUVENIR POSTCARD. This novelty card is made of wood. It pictures nineteen-year-old "Louisa" teasingly lifting her skirts. Standing beside her is four-year-old "Anna." The word Exposition is at the bottom—*Louisa 19 Anna 04 Exposition.*

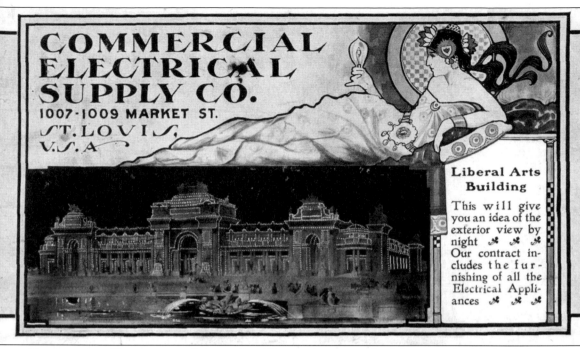

COMMERCIAL ELECTRICAL SUPPLY CO. 1007-1009 MARKET ST. ST. LOVIS, V.S.A

Liberal Arts Building

This will give you an idea of the exterior view by night ✤ ✤ ✤ Our contract includes the furnishing of all the Electrical Appliances ✤ ✤ ✤

COMMERCIAL ELECTRICAL SUPPLY CO. The modern marvel of electricity highlighted the start of the grand event. From the White House, hundreds of miles from St. Louis, President Theodore Roosevelt touched an electric key that set off the April 30, 1904 mechanized opening of the World's Fair. This marvelous illustration of art in advertising radiates the wonder of electric lights.

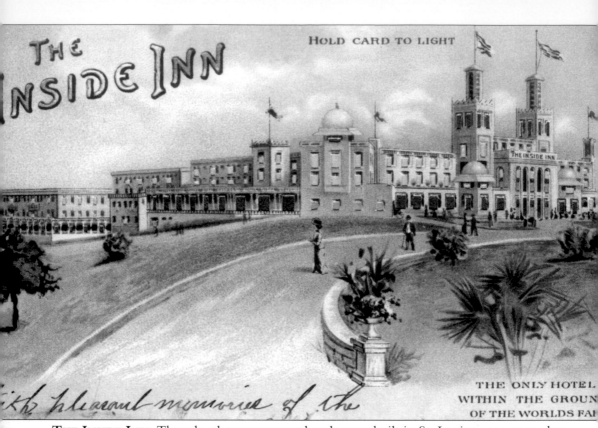

THE INSIDE INN. Though other permanent hotels were built in St. Louis to accommodate the Fair, the Inside Inn was constructed on the fairgrounds. A very attractive building, as depicted on this card, it lasted only as long as Exposition. In a series of Hold to the Light postcards, this particular one is the most rare.

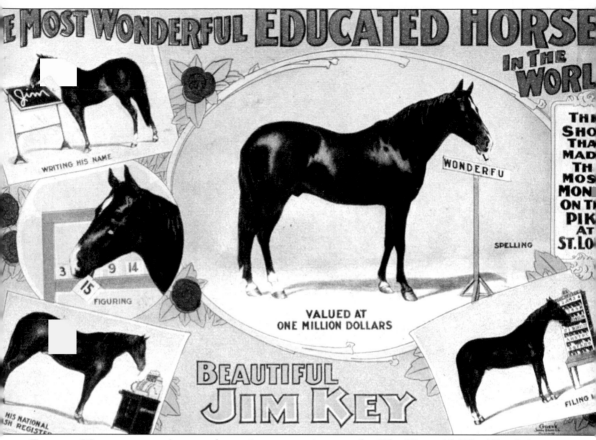

EQUINE MILLIONAIRE. Among the various attractions on the Pike "Beautiful Jim Key," the wonderful educated horse likely drew a large audience. A concession area, the Pike stretched over a mile, selling then unusual refreshments such as hot dogs, ice cream cones, and iced tea. Patrons could enjoy a culinary adventure while viewing extraordinary exhibits such as this equine millionaire.

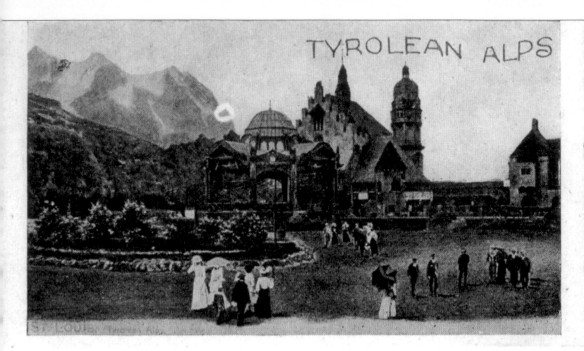

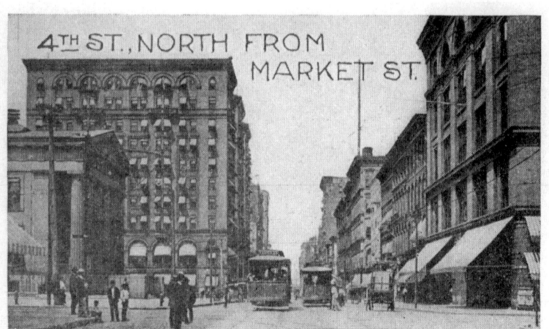

INSIDE SPREAD OF FOLDOUT ST. LOUIS SOUVENIR CARD. This foldout of the souvenir card shown on page 19 includes a scene from one of the 1904 Fair's exhibits on the Pike (see page

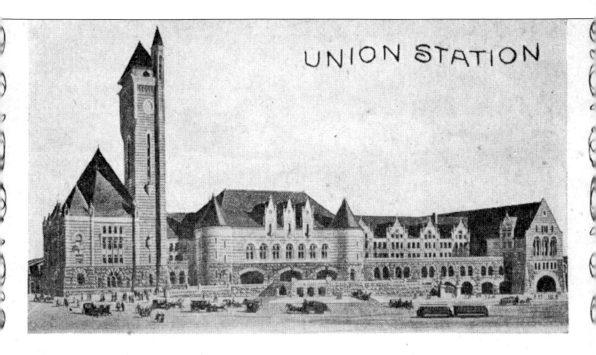

UNION STATION

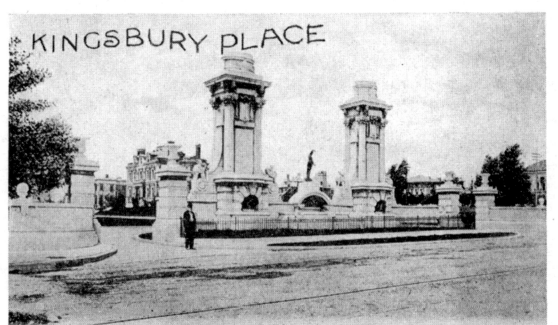

KINGSBURY PLACE

125). The Tyrolean Alps (upper left) simulated an Alpine village, yodeling and all.

BIBLIOGRAPHY

Gateway To America—An Illustrated History Of St. Louis. Kirstin N. Hammerstrom. 2002. Heritage Media Corp. Carlsbad, California.

The National Game. Alfred H. Spink. 1911. National Game Pub. Co., St. Louis. (Reprint 2000, Southern Illinois University Press).

Picture Postcards in the United States 1893-1918. Dorothy B. Ryan. 1982. Clarkson N. Potter, Inc./Publisher. New York.

St. Louis: Landmarks & Historic Districts. Carolyn Hewes Toft. 2002. Landmarks Association of St. Louis, Inc.

This Is Our Saint Louis. Harry M. Hagen.1970. Knight Publishing Company. Saint Louis, Missouri.

Where We Live—A Guide To St. Louis Communities. Edited By Tim Fox. 1995. Missouri Historical Society Press. St. Louis.